Robert Cumming

Slow Looking

Robert Cumming

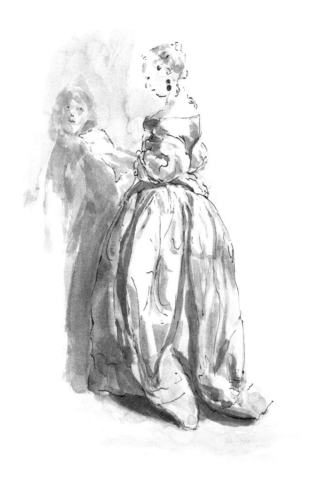

Illustrations

Gino Ballantyne

The Lutterworth Press

Slow Looking

Book One

Learning to Look

Bernard Berenson, the pioneer connoisseur of Italian Art who lived at the Villa I Tatti outside Florence (now The Harvard Center for Italian Renaissance Studies) came to believe that the direct experience of nature was better than the first-hand experience of art. As I grow older I am inclined to agree. I would also add to his observation the intimacies of a happy family life with children. Thus, my principal words of appreciation are for my wife Carolyn, our two daughters Chloe and Phoebe, our sons-in-law David and Edward, and our grandchildren Bertie and Sophia. To be with them, to look at them and to enjoy their company are experiences so full of delights and surprises that, for me, they surpass those of the four paintings in this book. Carolyn has created from a neglected wilderness a wonderful garden which constantly opens my eyes to the beauties of nature. I wish to dedicate this book to them all and to Carolyn especially for without her constant loving kindness, understanding and support Slow Looking could not have been written.

Robert Cumming

June 2024

The Lutterworth Press
P.O. Box 60
Cambridge
CB1 2NT
United Kingdom

www.lutterworth.com
publishing@lutterworth.com

Hardback ISBN: 978 0 7188 9805 2
Paperback ISBN: 978 0 7188 9774 1
PDF ISBN: 978 0 7188 9776 5
ePub ISBN: 978 0 7188 9775 8

British Library Cataloguing in Publication Data
A record is available from the British Library

First published by The Lutterworth Press, 2024

Contents

Preface

No book can hope to recreate the experience of seeing a work of art at first hand, any more than a book about birds can attempt to recreate the experience of seeing and hearing them on the wing and in the wild. Most books about paintings will bombard you with facts and figures and history, but I know from my own knowledge and experience that the history of the albatross and statistical information about the bird is as nothing compared with seeing that huge, majestic living creature soar into the sky over a Southern Ocean with outstretched wing tips dipping vertically to skim the surface of the waves.

Reading a book tends to be a fulfilling but solitary experience – and none the worse for that. A visit to the theatre, a concert, a sporting event, an art gallery or an art exhibition, is, I think, at its most fulfilling and satisfying when it is experienced personally and simultaneously shared with others. This book is an attempt to share my experiences of great works of art and recapture some of the excitement (and challenges) of seeking them out and looking at them at first hand.

Two essential things will be missing from this book. The painting itself, and your account of what your own eyes and your own experiences tell you (and which you might want to share). A small colour reproduction of a painting in a book gives no idea of the size of the original, is no substitute for the real thing, and in many ways is positively misleading. For this reason, we (that is the author and the publishers) have decided against colour reproductions. In general, because a colour reproduction inevitably changes the tones and hues of the painting itself, it also destroys its essential balance and harmony. Those latter qualities are best preserved in a good quality black-and-white reproduction. When Kenneth Clark published his book *100 Details from Pictures in the National*

Gallery, he included only black-and-white printed images for this very reason. He also observed: 'Just as a great river does not flow from a single source, but is made up of innumerable tributaries great and small, so the total impression of a work of art is built up of a hundred different sensations, analogies, memories, thoughts – some obvious, many recondite, a few analysable, most beyond analysis.'

In order to add to the innumerable tributaries, I asked my good friend Gino Ballantyne, who is a highly gifted draughtsman and painter, and a most acute and sensitive observer, to add his own impressions and thoughts, not as words but as his own images and interpretations. If you wish to connect with a colour reproduction of each individual painting and zoom in on details you will be able to do so in far greater clarity, detail and freedom than is possible on the printed page through the appropriate page on my website **www.robertcumming.net.** It is not a perfect solution, but it is perhaps closer to the experience of being together in front of the actual painting.

Finally, if you would like to share with myself, Gino and others, your own observations, comments and thoughts we have set up an online forum. You can find this by searching for **'Robert Cumming's Slow Looking'** on Facebook, where you will find my page. Again, there is no substitute for mutual and concurrent first-hand observation and experience any more than there is a substitute for the sight of the albatross. However, that is no reason for not attempting to do the best one can with the facilities currently available.

Foreword

How best to experience the world? In my case, directly through one or more of my five senses – sight, hearing, touch, taste, smell. I do know that my moments of greatest pleasure are when all five senses are stimulated simultaneously and harmoniously. Looking at a great work of art is a prime example, as are eating and drinking fine food and wine or being present at a grand opera or a first-class sporting event. On a humbler level, and even though I can do neither very well, playing golf, or duets on the piano, both of which require the senses of hearing, touch and sight to be at their most alert, have given me some of my most fulfilling experiences.

I enjoy watching how my small grandchildren explore their senses. Their experiences seem to be intense and entirely their own and mostly joyous. The way they assimilate these first sensations will be a major influence on the formation of their characters and personalities, and on what activities they choose to pursue in later life. I am also conscious that complications will arise when words are added to their awareness. It is through words that they will start to learn what other people experience. For example, sooner or later they inevitably will be told by someone in authority that what they see is not what they ought to see. Gradually their fresh eyesight will dim. Instead of believing the evidence of their own eyes, they may regrettably come to believe only the words they read or hear and see only what they have been told to see.

There are two ways of learning about a work of art factually and appreciating its merits aesthetically. One is to go and visit it at first hand and stimulate the senses, the eyes, the mind and the imagination. The other is to read books. Both ways are equally legitimate, but each has

a very different outcome. The problem with written words is that they can only report what the author has seen – most likely by means of a photograph or reproduction rather than the work of art itself – or thinks he or she might have seen or been told to see, or recount what she or he has read somewhere, or expound theories which are the product of the mind, not of looking.

Experience has taught me that everyone sees something different, and that each person looks at a work of art in an entirely individual way. This may seem like a statement of the obvious, but be warned. Most books about art, written by 'experts', will contain a statement, openly or implicitly that 'what we see here is. . .'. It is a remark which, for me, regularly provokes the response 'Well, you may do, but I do not. . . . Am I being blind or bigoted or is it you. . . ?'

There is a much-quoted Latin phrase 'Ars longa, vita brevis'. It is usually claimed to mean 'Life is short, but Art lasts a long time'. This claimed meaning is incorrect. What it truly means is 'Art (or skill) takes a long time to perfect, but life is short'. Creating any work of art requires huge courage and personal commitment from the creator. In making it, he or she lay his or her cards on the table, revealing not only his or her ability (or lack of it), but many of his or her beliefs, foibles, fears, passions, hopes and disappointments. Anyone who engages with a work of art should be willing to reciprocate with equal courage and commitment. Thus, it is on those occasions when the eyes and minds of the creator and the viewer of a visual work of art are in comprehending union that the greatest rewards are to be found. Turning the direct experience of a mute work of art into words is notoriously difficult, and very personal. This book is my attempt to do so, and why I have felt it imperative to lay some of my own cards on the table.

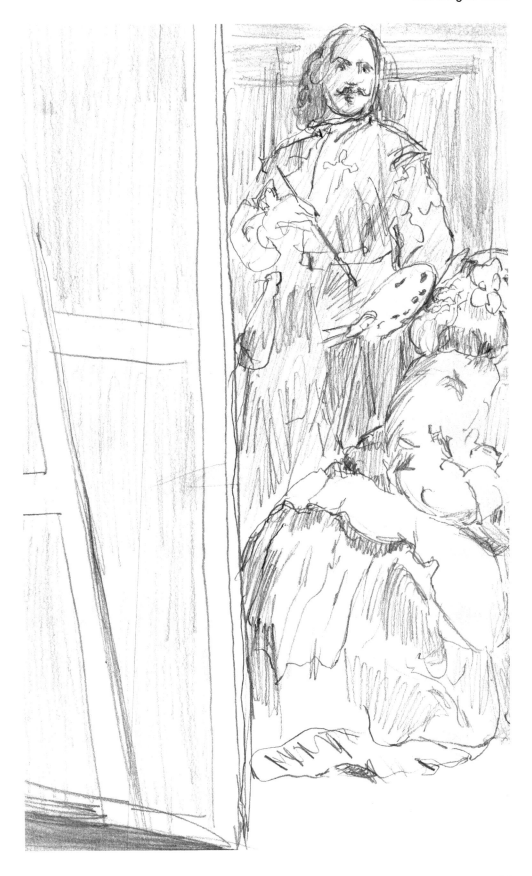

First tastes of aesthetic experience

I was not born into a family that took any great interest in the arts. We did not go to exhibitions, to the theatre or concerts, except under duress when my mother thought that we ought to. Nor did we read books very often. Such books as there were in the house were kept in a bookcase with glass doors which were difficult to open. There were some old children's books with pleasing illustrations by the likes of Arthur Rackham which I would look at secretly after I heard my mother say that books with pictures stifled the imagination. She probably did not mean it, but, being a child, I feared that by looking at books with pictures I was doing something wrong.

There were six of us in the immediate family: my parents, myself and two older brothers, and my widowed grandmother. We lived in a large, uncomfortable, gloomy Victorian mansion with two billiards rooms, stables, a piggery, a rookery, a walled garden and about four or five acres of land. We lived in the middle of nowhere, and in the full chill of

post-war austerity. There were no beautiful landscapes, rolling hills or winding lanes on our doorstep. The view from my bedroom window, across a couple of scrubby fields, was a line of belching factory chimneys. I was born shortly before the cruel and severe winter of 1946/47. The late 1940s were bleak socially and economically with strikes, high taxation, rationing and shortages of food, fuel and basic commodities.

'Nowhere' was Holderness in the East Riding of Yorkshire. In the whole of England there is no landscape flatter or bleaker than Holderness on a grey winter day. There was not a lot to look at or take an interest in, and finding beauty in large skyscapes is a sophisticated and adult pleasure. Post-war Hull was not beautiful. My first recollections are of bomb sites, the blackened remains of buildings now uninhabitable, with shops and stores squatting in cramped and temporary accommodation.

Nonetheless, Kingston upon Hull in its Edwardian heyday had been a handsome and flourishing city, on the up and on the move, a place with a hopeful future of prosperity. We lived there because my father's father, who had qualified as a doctor at the University of Glasgow, had moved there to establish a practice, and succeeded. My mother's father, whose origins were Irish, had established himself as a much respected member of the burgeoning Hull business community.

The menfolk of my blood relations were obsessed with sport, principally cricket and rugby. To have an interest in sport and to be successful at it was their yardstick of manhood and success in life. By and large they lived up to their aspirations. My father had been captain of the local rugby club. My elder brother had been captain of every sport at school, where he was considered something of a demigod because of his athletic prowess.

I did not fit easily into this milieu. I had very poor hand-eye coordination and I gained little pleasure from strenuous physical exertion. At school I showed myself none too good at any games but shone at music, and I had some success in school plays. Even so, I longed to go home with a team photograph, House Colours or a silver cup with my name engraved on it, as did my brothers. There was a gap of ten years between me and my elder brother, and as both brothers were often away at boarding school and I had little in common with them anyway, I spent much time in my early years creating my own entertainment. A principal occupation was model theatres for which I could design the sets, write the plays, direct the actors and, by propping up a large mirror in front, watch the performances. I also liked making things and would spend hours building houses with 'Minibrix' or making floorplans and elevations for grand projects such as hotels. We had a battered set of Arthur Mee's *Children's Encyclopaedia*. I was not particularly interested in the information they contained, preferring the pages that were headed

'Things to Make and Do'. We had an old pre-war Imperial typewriter that my father brought home from his office when they had discarded it. On this I would hammer out embryonic books or newspapers, and catalogues for the 'British Furnetchur [sic] Company'.

I have a precise memory of four architectural lithographs which hung in the hall, most notably one of the drawing room at Broughton Castle. I can now identify it as by Joseph Nash from a set entitled *The Mansions of England in The Olden Time*, published in 1905. From the dining room I can clearly recall four early-nineteenth-century prints by Henry Alken of tophatted gentlemen shooting in a wood. Those images fostered an already developing desire for adulthood and a wish to be a part of a greater historical continuity. In the fullness of time my wife and I settled in a house not far from Broughton Castle, and we became acquainted both with the Castle itself and the family who had lived there for twenty-two generations since the fifteenth century. The only two sports at which I have achieved modest success are golf and shooting and I have spent many a happy afternoon with a handful of companions pursuing the odd game bird through a wood in similar vein to the sportsmen in the Alken prints.

The only member of the household who had any understanding of my interests was my grandmother, my mother's mother. She had her own sitting room at one end of the house. In that room she quietly encouraged my desire to design and make things and taught me the enjoyment of backgammon and card games such as beggar-my-neighbour, snap and rummy. We made occasional expeditions into town, by bus, to the Ferens Art Gallery or to Carmichael's who sold 'nice things' including classy and expensive antique furniture, gilded mirrors, silver, porcelain and leather goods. She was gently sowing seeds of aesthetic awareness and experience in her young grandson. She was a good judge of character and I suspect that she knew full well what she was up to.

One of her most valued possessions was a mahogany-veneered Beau Decca radiogram and through it I first tasted the pleasures of true aesthetic experience – Handel's *Messiah*, Elgar's *Pomp and Circumstance March No. 4*, the 'Prelude' to Act III of Verdi's *La Traviata*; the 1930s crooner, Turner Layton singing 'Transatlantic Lullaby'. She had a Royal Copenhagen glistening porcelain seagull that was cool and pleasing

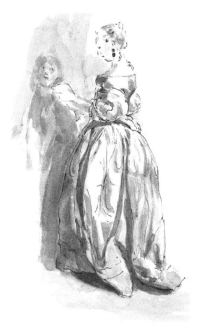

to the touch; an Edwardian bracket clock that had been a wedding present in 1907, solid and reliable with an agreeable tick and chime (I eventually inherited it); and above the fireplace an elaborately framed print of a not-so-beautiful young lady in a long satin dress, reading a letter, beside a table with two other people and with a small dog asleep on a stool. Like the prints, it fascinated me and registered indelibly on my memory. I now know what it was: a high-class colour reproduction, issued by the Medici Society in the early 1920s, of a painting in the Royal Collection by the seventeenth-century Dutch artist ter Borch.

I suspect that my father and brothers considered my interest in music, theatre and the creative arts to be at worst an embarrassment, and at best an oddity: a potentially unfortunate handicap which, like a squint,

if left to itself, I might grow out of and recover from. One of the accepted ways, then, of correcting any incipient aesthetic or intellectual 'squint' was to send a boy to a boarding school which prided itself on its sporting rather than scholarly prowess, in the hopes that the regime would knock some sense into him. In other words, for the time, I was part of a very normal provincial, Northern, well-to-do, middle-class family.

We jogged along together reasonably well, for most of the time, neither excessively happy nor unhappy. However, tragedy was waiting in the wings. For most people, calamity is usually experienced at second hand and often through the medium of art – for example, Shakespeare's *King Lear*, Tolstoy's *War and Peace*, Verdi's *La Traviata*, Mozart's *Requiem*. For better or worse I experienced tragedy at first hand early on in life. Before I had reached puberty, my middle brother was dead. Before I left school my father had also died. It was only later, through art, that I became reconciled to these two misfortunes.

My brother, Andrew, had broken his nose playing rugby at school and it had been decided he should have an operation to unblock the stricture. It was a routine operation, but required a full anaesthetic, and had been arranged to be done locally during one of the Easter holidays. I can remember him leaving home to be driven to the nursing home in Hull. I never saw him again. After three lingering days he was dead. Nobody ever said what had gone wrong, and I do not remember his being brought to mind in family conversations.

Before the War my father had contracted tuberculosis from which he had recovered. Soon after I went to my first day school, the disease returned. One of my earliest memories is of his being ill in bed at home, and of whispered conversations between adults that he had been coughing up blood. He was treated by isolation for the best part of a year in the local sanatorium. He was given a new drug called M & B and was seemingly cured. Unfortunately, it later transpired that although the drug was effective against tuberculosis it had side-effects, one of which was to kill the kidneys. For the last years of his life he was an invalid, more and more withdrawn, occasionally going to the Middlesex Hospital in London for primitive and distressing kidney dialysis.

I came home one autumn half-term from boarding school, just as I was making preparations for A-levels and thinking about entry for Oxbridge. My father was confined to bed. The local doctor came out and he explained to me how desperately ill he was. My father was taken to hospital in an ambulance and died before the week was out. He was 53 when he died, the same age as my mother.

Before he died my father unintentionally gave me a hugely important aesthetic experience, together with a taste for modern art and foreign travel. In dying when he did, he unwittingly bestowed on me several benefits which had a critical influence on my future life.

The first time I went abroad was with my parents to see my, now only, brother who had been stationed with a tank regiment in Osnabruck, Germany, for his National Service. My father was not keen on 'abroad', but he was willing to go to see my brother because the trip meant he could include a nostalgic stay in Hamburg where he had worked briefly as a young businessman in the 1930s. Our visit there coincided with a large Picasso retrospective at the Kunsthalle, and we went to see it. As we walked round the exhibition, I sensed that my father's patience was shortening. In front of *Guitar* (1926), an assembly of string nails and an old dishcloth, he exploded with anger and promptly marched us out of the exhibition and out of the museum. He was not going to tolerate any more of such nonsensical rubbish and he would not allow his family to be contaminated by it. When we came home, I painted a picture in what I thought was Picasso's style. My mother thought it showed 'promise'.

In his will, my father left me a small share portfolio which meant that, although I would have to earn a living, I could be financially independent whilst I worked out what to do. That financial independence would prove to be a huge blessing. Also, if my father had not died that autumn, I wonder if I would have secured entry to Oxbridge? In those days Oxford and Cambridge colleges set their own individual entrance exams, and applicants resided in college to take them and be interviewed. I applied to St John's College, Oxford to read PPE (Philosophy, Politics and Economics), and Trinity Hall, Cambridge to read I knew not what, possibly Economics. I was aware that my school had written to each college to explain my recent family circumstances, and I suspect that

tipped the balance in my favour. Both St John's and Trinity Hall offered me a place. None of my immediate family had been to university, but there was an East Riding connection with Trinity Hall, and it was always assumed that was where I would go.

I fell in love with Oxford and thought that PPE would be the perfect degree for me. However, wishing to be dutiful, obedient and pleasing to my family, I accepted the offer from Trinity Hall. Anxious to make a complete break with the recent past and start again, I eventually opted to study Law, which was one of the few subjects that required no previous background knowledge and experience and had the advantage that it might lead to a career. I do not regret the decision for one single moment, although it turned out to be a wrong turning. I also came to understand that being dutiful and obedient does not cause people to love you, and that, when making a choice, it is probably better to follow your heart and do something that engages your passions rather than do something that your head tells you is 'sensible' and 'right'.

Between my brother dying and my going to Cambridge I had been in a state of limbo, developing very little physically or emotionally. Trinity Hall prided itself on a warm and supportive ethos, and I began to emerge from limbo. I made friends for the first time. I enjoyed my study of the law, was good at it, understood the point of it, gained a good degree and won prizes. Every week for three years, I had a one-hour group tutorial with J.W. Cecil Turner, one of the senior Fellows of the College. The same age as my grandmother, he was a remarkable individual. A former county cricket player and the father of six children, he had become crippled with arthritis which rendered him immobile. Every day he would make his way into college with painful difficulty in a motorised three-wheeled single-seat vehicle, in order to sit in his rooms and teach the young. At regular intervals he would intone 'I am not going to teach you facts. You can get those from books. I am going to teach you to think!' And he did just that. For me it was a revelation and a liberation, and I shall always be in his debt.

I joined the Middle Temple, pursued the ritual of eating 'Dinners', sat the Bar exams and became a barrister. A friend arranged a place for me as Marshal to a High-Court judge on circuit, who in due course secured a pupillage for me in his old chambers. My future seemed assured. Then doubts crept in. Drafting endless divorce petitions or writing legal opinions on obscure points of law was a lonely occupation that appeared to have very little to do with the more pleasurable aspects of life and living.

My judicial hero was Lord Denning. I warmed to his creative manipulation of the law to ensure that no one left his court suffering what he considered to be a moral or social injustice. However, I soon discovered that to most of the Bar and judiciary he was an anathema. Their priority was certainty and adherence to the rules. For them, Tom Denning's creative interpretations could only lead to uncertainty and lawlessness. In the end, sitting in Middle Temple Hall for lunch, I would look at the barristers who were ten or twenty years ahead of me and think 'Do I want to be like you in ten or twenty years' time?' When the answer came back repeatedly 'No I do not!' I realised it was time to move on and try something else.

Some of my friends from Cambridge were establishing themselves in careers in the art world: museum curatorship, antique dealing, the auction houses or publishing. It began to dawn on me that they were better company to be with and that, although less well remunerated

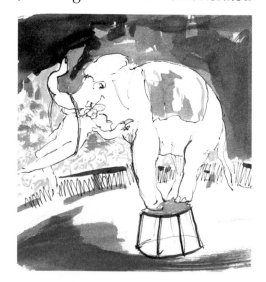

than lawyers or bankers, they had a rather more fulfilling lifestyle and greater job satisfaction. I had also begun to buy 'nice things'. I bought decent antique furniture, pictures, the odd piece of silver, prints, and took myself off to exhibitions, concerts, theatre and opera. Someone tipped me the wink that 80-year-old Dame Laura Knight, whose work I admired, was short of a penny and willing

to sell a drawing to people she liked. I went to see her. We hit it off, and I left her house in St John's Wood, £10 the poorer and the proud owner of a circus drawing done in the 1930s. It remains a treasured possession.

I am not sure when I decided to risk an uncharacteristic leap in the dark to see if I could make it in the art world. There was no epiphany. I suppose that, fundamentally, the seeds that my grandmother had sown, had begun to sprout. Nonetheless, there remained the practicalities of how to enter the art world. I did not want to be a 'go-to' legal adviser on the fringes. I wanted to be knowledgeable, to have expertise, to be in the thick of it. The clock was also ticking, and if I did not make the move now it would be too late.

The only answer seemed to be a degree in Art History. In early March I went to see my old tutor at Trinity Hall. He agreed I could return to the college to do two years of the undergraduate Art History course, starting in the following autumn. It occurred to me, merely as a matter of common sense, that before studying the history of art it would be a good idea to acquire some first-hand understanding of how works of art are made. On nearby Camden Hill was the privately run the Byam Shaw art school, so I knocked on their door, explained my situation and asked if they could help. They responded enthusiastically: 'My God! An art historian who wants to get his hands dirty and find out how art is made? Don't let him get away!' Only when I was in the middle of the Cambridge History of Art course did I wake up to the significance of this remark. They gave me free run of the art school. I learned how to mix paints and the different techniques of printmaking. I sat in life classes and studied the human figure. I had a most rewarding six months, learning about looking and seeing, realising just how challenging and puzzling they can both be, yet how, with patience and persistence, they can be so hugely life-enhancing.

Another good friend suggested that I ought to spend some time in Italy to see the art and architecture of the Renaissance at first hand. Having never been to Italy, that, too, seemed to be an attractive proposition. I put a short advertisement in *The Times* personal column seeking a suitable house to rent somewhere in Tuscany and received only one credible reply, offering a house in the middle of Cortona for July and August.

I set off in a car piled high with everything I thought I might need, including an easel. During that summer the flowers that had sprouted from my grandmother's seeds opened their petals and turned their faces to the sun.

Cortona in those days was not a holiday destination for villa-owning wealthy foreigners. The town was slightly down at heel and visitors from abroad were few and far between. There was a small expatriate community of writers and artists who clasped me and my friends to their bosoms and looked after us. Our youthful group was a curiosity to the Italian local inhabitants, and they welcomed us with the greatest courtesy and generosity. The elderly aristocratic Umberto Morra – 'Il Conte Rosso' – was especially kind and understanding of my change of direction and aspirations. He had been Bernard Berenson's closest confidant and enjoyed a warm friendship with Kenneth Clark, the creator of the pioneering television series *Civilisation*. He invited me out to Cortona for the following summer to stay at the Villa Morra whilst I struggled to come to terms with the Art History course at Cambridge.

Reading books, rather than looking at works of art, is the be-all and end-all of History of Art courses. If you are running a degree course with written exams at the end you must have words, otherwise there is no means of assessing a student academically. The German academic, Erwin Panofsky, who established the framework for post-war pedagogical art historical studies based on the rigorous scrutiny of documents and the historical contextualisation of works of art, once exclaimed: 'I hate originals [actual works of art]! They ruin the best theories I formulated on the basis of [black-and-white] photographs!'

When I signed up for the Cambridge course, I did not know any of this. The History of Art Department was next door to the Fitzwilliam Museum which is one of the finest museums in the United Kingdom, with an astonishing range of works of art, beautifully displayed. Most members of the faculty never set foot inside the museum, and they certainly did not use it to teach their classes. In the first year every student was required to do a module called 'Approaches to the History of Art'. Basically, this meant spending the rest of the year in the University Library reading books by people I had never heard of, writing about works of art I had never seen, and composing essays to report what I had read.

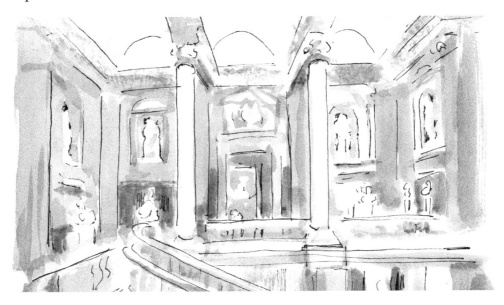

It was inevitable that I would be disappointed in such a course, and it would have been a total disaster had it not been for two remarkable members of the faculty who were willing to make their students look at real works of art and ask them, not what they had read, but what they could see with their own eyes. Duncan Robinson, a young curator at the Fitzwilliam and a dedicated teacher (even when he was simultaneously the Director of the Fitzwilliam and Master of Magdalene College, he continued to teach the young) would show us prints and drawings and discuss them as living works of art rather than as dead historical documents. He was as much excited by modern art as by Italian Renaissance masterpieces. We were of similar age, and he generously helped me to manoeuvre around my struggles.

In my second year I chose to study a course on Modern European Art 1880-1940 which was taught by a remarkable Australian called Virginia Spate. She had herself been a painter and regularly took her students into the Fitzwilliam. She sweated blood for them. We were also of similar age. For my first essay for her, and wishing to impress, I wrote about Picasso and one of his early Cubist works. In my own opinion, what I had written for her was masterly. Using all my legal skills and training as a barrister, I presented carefully selected facts, wrote elegantly honed prose, and interspersed my own meticulous words with thoughtfully chosen quotations by Picasso and by the eminent scholars of art history. Legal judgements are richly sown with precedents and citations from authority: once a lawyer, always a lawyer. When I went for my one-on-one tutorial with Virginia, it was immediately apparent that she was not overly impressed. With great insight about me, and with an adroit instinct for teaching, she politely invited me to read aloud to her the first page of my essay. As I did so I saw her take a book from her shelf and open it at a large-scale illustration of the painting I had written about. After I had finished reading, she looked me squarely between the eyes and, showing me the illustration, said: 'Now, Robert: which square inch of that painting were you referring to?' It was devastating, but in that instant, scales fell from my eyes. From then on, I understood what to do. Those two years of study were worth it for the sake of those few minutes. How often since then, when trying to write about a work of art, have I thought back to that day and asked myself, over and over again: 'Now, Robert: which square inch are you referring to?'

Learning to look

By an extraordinary stroke of good fortune, I found employment within a very short space of time of completing the Cambridge course. I answered a newspaper advertisement from the Tate Gallery, was granted an interview and offered a role in the Education Department, starting in the autumn.

My principal task, as the junior member of the Education Department, was to stand in front of works of art and talk about them in an appropriate way to whoever was in the audience – schoolchildren, university undergraduates, foreign visitors and dignitaries, members of the public who came for a daily lunchtime lecture – in a word, to all and sundry. It was a baptism of fire. On the Cambridge course, besides historiography, i.e. the history of written art history, I had studied Titian, English architecture 1700-50 and the module on modern painting and sculpture. The rest was a complete blank. To cover my ignorance, which was profound, instead of pontificating on things mugged up the night before, I stood in front of my audiences during the lunchtime lectures, looked them between the eyes and asked: 'First of all, tell me what you can see.' There would be a stunned silence, but if I waited long enough somebody would hesitantly point to something, another would point to something else, and with luck a third person would disagree and say that in looking at those same square inches they had seen something quite different. After that, a lively debate usually ensued, first to establish some sort of consensus about what was there. This led on to a discussion about what that could mean, and how the work of art might be understood or interpreted.

The experience of those lunchtime lectures in front of an actual work of art and a live audience with up to 30 or 40 pairs of eyes

taught me many important things. Above all, I learned that no two people see the same thing. I do not mean interpret the thing they are looking at in different ways. At its most banal, I mean that what one person identifies as a table, another person will identify as a chair. Ultimately, of course, there is no table or chair. What they are looking at is, in the case of a painting, a piece of canvas with paint and marks on it.

We'll show you the works

at the Tate Gallery

I learned that a work of art is most enjoyable when it is seen at first hand and shared with others, much in the same way that food and wine come into their own in a meal tucked into with kindred spirits. As with a meal, those audiences enjoyed being asked to participate fully in direct experience, to say how their senses were stimulated and why, or to discover that some of their fellow guests had different experiences. How dispiriting would it be to sit at a meal table and never be allowed to let a morsel of food or wine pass one's lips, whilst someone drones on about the history of food or the theory of wine? Similarly, my lunchtime audiences did not want to know only how the work of art they were looking at fitted into the history of art or into the most recent fashionable theory about it. I fully accept that in the absence of a work of art itself, for example in a lecture with inadequate slides which makes every image appear to be the same size, distorts the original colours and completely loses the subtlety and texture of a paint surface, the void can, perhaps, only be filled by spouting a barrage of facts, art historical jargon, or trying out a new theory however

nonsensical. There is a comparison to be made between a peach eaten straight from the tree, and tinned peaches from a supermarket shelf. If asked to say something about the latter, I too would probably be reduced to reading out the information written on the label.

I would introduce references to the life of the artist, to history, literature or music to fill in the context of the work of art where required, or make cross-references to other artists if there was a suitable work of art within eyesight. I also learned that, being human, my audiences enjoyed anecdote and gossip. Yarns and tittle-tattle are to biography and history what salt and pepper are to cooking. Without seasoning food can be very bland and uninteresting. Too much seasoning, on the other hand, deadens the senses and instead of stimulating the palate simply paralyses it.

As my audiences began to discover what a real pleasure the act of looking can be, they also wanted to know about the techniques and tricks that the artist had used to create the picture or sculpture we were examining. Again, there is a food analogy. If you have tasted some particularly scrumptious dish that has stimulated the taste buds, it is natural to ask what the ingredients were and what the cooking process might have been. I suspect that is one of the reasons that television cooking programmes are so popular. People like to know how it is done even if they have no intention of doing it themselves. So, I learned that my audience could become engaged visually and directly with the work of art if I showed them the underlying structures, the techniques used to create illusions of space and light, how an artist would introduce rhythms, cadences, contrasts, motifs, symbols, and play with them or repeat them as would a musical composer. I tried to draw them away from the idea that a picture is a single image like a snapshot but might be well be a complex construction containing different scenes, viewpoints, transitions, close-ups, storylines or timeframes, as does a well-edited movie.

I also learned that the sharpest eyes belong to small children. They see things and details that no adult will ever see. The reason is that children travel light. Most adults travel with too much cultural baggage. They surround themselves with heavy cases with impressive labels such as

'Irrelevant Detail', 'Cleverness', 'Theories'. All this luggage can be used to intimidating effect, especially if the contents of the individual bags are not examined too closely. Too many people succumb to a regrettable temptation to be seen with a vast array of firmly locked luggage in order to appear truly well travelled. It takes great courage to travel light, especially if everyone else seems to require so much baggage.

A work of art, be it a painting, sculpture, opera, ballet, orchestral music, a play, a novel or a poem needs time. None can be understood in an instant. Getting to know them can take a lifetime. In those lunchtime lectures we would spend up to 45 minutes – longer if it was going well – in front of a single work. Even then we would only scratch the surface. I must have discussed Picasso's *Three Dancers*, Matisse's *The Snail* and Turner's *Hannibal Crossing the Alps* with well over a hundred different audiences. Each time I would see, or a member of the audience would point out, something that I would swear had not been there the last time I looked. That is one of the qualities of a truly great work of art. They are inexhaustible deep wells from which the bucket can be refilled time and time again. Lesser works of art might hold my audience's attention for ten minutes or so, and then we would discover there was little more to see or talk about.

Public art galleries and exhibitions seem to go out of their way to make it impossible to spend time with a work of art. I do not believe it is deliberate. On the other hand, they could do more to help. For example, standing is tiring especially as one gets older. If you go to a play or concert, there is the option to sit comfortably during the performance. If you are going to spend equivalent time with a work of art in a museum or art exhibition you need a comfortable resting place. I always ensured that my lunchtime audiences had access to folding stools and encouraged young children and students to sit beside me on the floor. Do national galleries provide a comfortable perch in front of their iconic masterpieces? Is there ever a place to sit in front of the key work of art in a blockbuster exhibition? I realise that present-day directors are under constant pressure to display as many works of art as possible, and to get the most visitors through the front door and then persuade them to spend money in the shop and café. Long gone are the days when a

national gallery regarded its principal justification to be that it was a place for the quiet contemplation of art rather than a money-making tourist trap.

I have also learned to do something which my father had never been able to do, and which legal training is designed to prevent. It was my shrewd tutor at Cambridge, Virginia, who alerted me to its importance. She had asked me to write an essay on Mondrian. Applying her advice 'which square inch are you referring to?' I had, in all sincerity, pointed out that because his small abstract pictures consist mostly of a plain white background with a few black horizontal and vertical lines, plus two or three blocks of solid primary colours, there was not a lot to refer to. Consequently, there was not a lot to talk about in terms of interpretation or meaning. I was not trying to score any points. She listened politely and then asked me: 'Are you able to suspend disbelief?' It took time to digest the significance of her observation, but over time I have come to see the significance of it. Opera requires a major suspension of disbelief, otherwise it is an absurdity. Any painting, which in reality is simply an agglomeration of coloured dabs and marks on a flat surface, also requires an ability to disbelieve that is all it is. It is relatively easy to achieve it with a figurative painting for there is always the basic pleasure of recognition. With an abstract painting where there is no such easy recognition, it requires a much more conscious effort to suspend disbelief. Once achieved, however, the rewards can be considerable.

Was that why my father stormed out of the Picasso exhibition in Hamburg all those years ago? Confronted with Picasso's *Guitar* of 1926, which in reality consists of a framed piece of painted canvas, about three feet by four feet, onto which an old grey dishcloth with a hole in the middle has been placed slightly off centre, some string, some paper, and about sixteen nails pushed through from the back so that they stick through the dishcloth with their sharp points projecting, he could not suspend disbelief. He was a pragmatic Yorkshire businessman and suspending disbelief was not and never would be part of his way of life. On the other hand, I do not think my father would have had too much difficulty in suspending disbelief in front of a Michelangelo or a Turner. He would have considered that they fulfilled a preordained and proper

function like a well-designed spade. Nevertheless, when you stand in front of Michelangelo's *David* you do have to forget that it is only a block of white Carrara marble and enter a realm in which it becomes more than a human form. It becomes the embodiment of an idea and emotion for which the human form is only a symbol and an expression. When you stand in front of a Turner sunset you must forget that you are looking at a piece of painted canvas in a gold frame and pass through that into a vision which enhances the senses and reveals qualities and emotions that have never been fully experienced before. In each of these cases it is not difficult to suspend disbelief because both exist within an established framework and a convention. We know, almost instinctively, what we are supposed to do when we stand in front of them.

Does the ability to suspend disbelief mean that every dishcloth can become a work of art? Absolutely not, although this is something that many artists and curators have yet to realise. Some dishcloths (or unmade beds), however fancily labelled, and however cleverly explained in art historical jargon, will remain forever what they are: a dishcloth (or unmade bed) trying to be something that it can never hope to be. Some

blocks of marble, although carved into a human form, remain resolutely blocks of marble whose only claim to fame is a high price ticket. Only in the hands of the greatest masters can the magical transubstantiation be made to work.

I loved the few years I spent at the Tate Gallery. I loved its eccentricity and the evangelical zeal of the staff. It was a unique institution, housing in a single building on Millbank two irreconcilable collections. Having entered

the portico you turned left to walk through the galleries devoted to Historic British Art, and right to walk through the galleries devoted to Modern and Contemporary International Art. The curators who set the museum's agenda were the mad enthusiasts who were united by a passion for modern and contemporary art. Anyone who shared that zeal was welcomed regardless of background, education, social status, age, gender, ethnicity, dress, manners or accent. We all passionately believed that the principal purpose of art was to make the world a better, more interesting, more beautiful and more humane place. Money and financial value were of no interest. At that time modern and contemporary art were still a minority interest, dismissed as beyond the pale by many outside the art world and by many within. Picasso was the most admired exemplar of this faith.

Would I have stayed at the Tate Gallery? Had I been able to foresee what that admirable institution would turn into, certainly not. Nor am I sure I was ever cut out for museum management with its bureaucracy, politicking and petty feuds. I prefer to be my own boss and run my own show. So, when I was offered the opportunity to be exactly that, I took it. Paradoxically it was the commercial art world that gave me the chance to fly my evangelical kite.

In January 1978 the Christie's Fine Arts Course was launched. I moved into a shared office at 8 King Street, St James', in London, with a tiny table and a chair held together by a string. There was no lecture room, no students, no staff, no syllabus, but the expectation that some 80-odd students would have signed on and paid their fees by the middle of September. It was madness, but it succeeded beyond all expectations.

The Paintings

Introduction

In the following chapters I have tried to explore within the limitations of a book some of the visual, aesthetic, creative and intellectual hallmarks of a great masterpiece.

Ideally, we would be a small group in front of the work of art itself, sitting in a semicircle so that each member has an unrestricted full view of the work of art, as well as of the faces and reactions of the others as we debate and question our different observations and interpretations.

The origin of this book was a light-hearted lecture that I gave many years ago called 'Desert Island Pictures'. It was a straight theft of the radio programme *Desert Island Discs*, the longest continuously running radio programme in the history of broadcasting. The format is a half-hour chat with an interesting personality about what makes them tick, interspersed with brief excerpts of music from eight records of their choice. The programme presupposes that the guest will be stranded alone on a sandy sun-kissed desert island with an old-fashioned portable wind-up gramophone, the discs having a playing time of scarcely more than two minutes.

I thought it would be interesting to be stranded on a desert island with eight pictures of my choice. In that remote retreat there is no one to consult, no library, no internet and no access to information other than recollection and the cultural baggage that the castaway brings in his or her head. In other words, all the intellectual apparatus on which academic 'Art History' is utterly dependent, is non-existent. I would have no resources other than my own eyes, my faulty memory, my personal experience and imagination, and yet have all the time in the world. In other words, I would have to investigate qualities and possibilities that are beyond the scope and range of conventional academic Art History which too often becomes so obsessed with cultural theories, factual minutiae and obscure documentation that it forgets to look at the work of art itself and takes no pleasure in actual looking.

Clearly, I was never going to be on an actual desert island with my chosen pictures. Fortunately, happenstance presented an interesting alternative. During the Covid lockdown when no one knew how long our isolation would last, we might as well have been stranded on desert islands. I put my eight pictures in turn on my large computer screen and looked at each of them for days on end. I kept a diary to record day by day what I saw, what I thought, what I remembered and what I imagined. I resolutely resisted the temptation to look up anything on the internet or take down a book from my library shelves. It was a thrilling experience because each painting (albeit in reproduction) revealed itself to me as never before, and by simply letting myself experience and enjoy what I saw, I discovered remarkable things about each painting and myself. I hesitate to say it was a life-changing experience, although I believe it was. It certainly changed my way of seeing and the way I experience works of art.

I never had any hesitation in choosing these four pictures – the next four proved to be much more difficult. I present them in the order in which I chose them. For me, Velázquez' *Las Meninas* is the greatest painting in the world. Personally, the little Infanta Margarita reminds me of my two blond daughters and how they were at that age. The painting has also helped me come to terms with the misfortunes of my own family. I chose Fra Angelico's *The Cortona Altarpiece* because artistically it is everything

that the Velázquez is not, and because it links me directly with the place and occasion of my own discovery of happiness and love. Both pictures have deep moral, intellectual and spiritual content, so for my next painting I chose Canaletto's *Arrival of the French Ambassador in Venice* since it makes the point that great art need not aim for seriousness or profundity – entertainment may serve just as well. The final choice of the Jackson Pollock was because I wanted something that had been created in my lifetime, and because it reminds me that no life is beyond the hope of redemption, and that recuperation, consolation and salvation, is one of the principal reasons for artistic inspiration and creation.

Las Meninas (1656)
by Diego Velázquez
is in the Prado
Museum, Madrid

After Velázquez,
ink wash on
watercolour paper

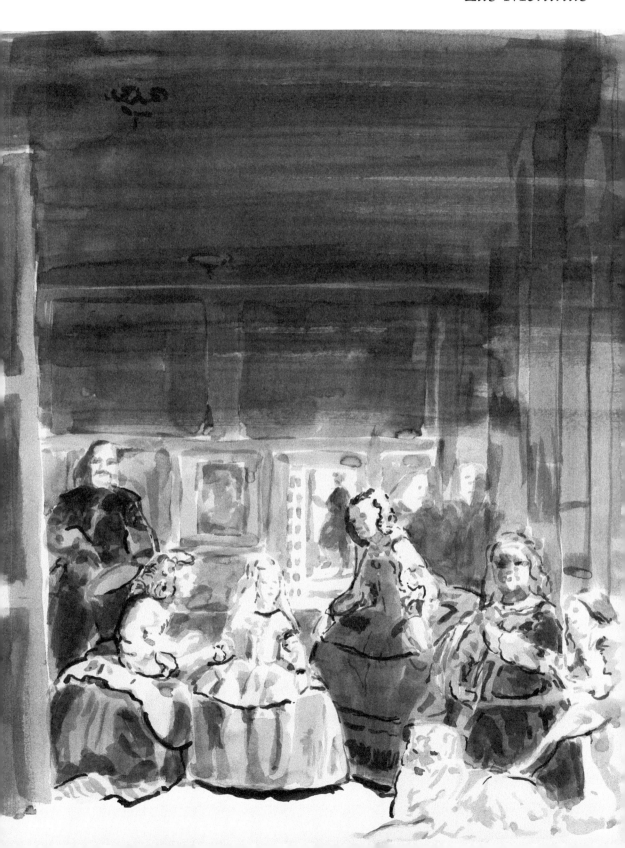

Velázquez

Las Meninas

Our first picture takes us to Madrid, to the Museo del Prado, which houses one of the finest collections of European art. At its heart is the former Spanish royal collection. The area where the museum now stands was once a meadow, i.e. a *prado*. In the early eighteenth century, the French Bourbon dynasty succeeded the Habsburgs as monarchs of Spain, and at the end of that century Charles III decided to urbanise the area and endow Madrid with a grand network of broad streets and monumental buildings in the French manner. Work was interrupted by the Napoleonic War and our building was finally opened in 1819, by his grandson Ferdinand VII, as a new Royal Museum of Paintings and Sculptures.

Ideally we would be a small group, and have a whole day to ourselves, comfortably seated, alone with Velázquez's *Las Meninas*, sharing what we each see and exchanging opinions, interpretations and personal thoughts. As this is not possible, and since this is a book, the only observations, thoughts and opinions set out are mine. I expect that some, maybe many, are different from yours.[1]

You should know me well enough by now to anticipate my first question, whether you are seeing *Las Meninas* for the first time, or for the hundredth – 'What can you see?' As this is a book, and we are not in Madrid and you cannot reply immediately, may I give you my diary entry for 18 April 2020, which is when I started writing about the pictures I might take to a desert island.

[1] Please refer back to the Foreword where you will be able to find links that can take you to the colour reproductions of each individual painting. You can use them to zoom in and explore; you are bound to see things I have missed and been blind to.

For better or worse this is what I see, or think I see, today, with the caveat that it may not be what I see tomorrow.

It is a large painting, almost square, over 3m tall (over 10 feet) which means that the figures are nearly, but not quite, life-size. In the painting the artist depicts a number of figures gathered together in a large room. They are situated in the bottom half of the painting. Above them is a large empty space, in which I see paintings hanging high on the walls. What is depicted is mostly ceiling. On the right-hand side are tall vertical window-like spaces. I cannot actually see windows, nor can I look out from them. The figures are arranged in three receding rows. Those in the front row are all well-lit. Those in the second row are in shadow. In the distance and in the third row is a man standing in a doorway, silhouetted, and there are two figures in a thick black frame, of which I can see only the upper halves.

Reading from left to right: on the far left is the back of a canvas on a stretcher which reaches nearly to the ceiling and looks to be twice the height of the man painting it. I cannot see what is on the other side of the canvas. The man to the right of it, appears to be middle-aged. He is dressed in black, and on his chest is a red cross. He tilts his head which has long hair and a moustache slightly to the left, and he is looking out of the picture toward us. He is holding a long paintbrush in his right hand. In his left hand he holds an artist's palette and mahlstick.

On his left – to the right as we look at him – is a young woman, dressed in black and white, showing her right profile, kneeling, and attentively holding something small and vase-shaped in her right hand which she offers to the child who stands in the middle of the painting. This child is to all appearances female, very young (probably between four and seven years old?), wearing a whitish coloured dress, and she appears to take in her right hand what is offered to her. She has long pale-gold blonde hair which is very carefully coiffured, and she turns her head slightly to the left in a pose which to my eyes seems deliberate and self-conscious. She looks out of the canvas with the sort of glance she might make

if she were looking at herself in a mirror. At her left-hand side is the standing figure of another young woman, elegantly dressed in grey and white with a red something or other attached at the wrists, who leans towards the young child in a pose which I would describe as attentive.

On her left, dressed in black and white, and in female dress, is a squat figure with a square lumpy face that could be male or female, with long brown hair that is brushed but not coiffured. To the left of this figure and on our far right is a smaller figure dressed in red trousers, young looking, presumably male, who places his left foot on the haunches of the large dog, with a gesture that for me implies stroking or massaging, which the dog appears to enjoy. Behind the three figures on our right, in the second row, and in shadow I see a middle-aged man dressed in black, his face indistinct, and a middle-aged woman dressed like a nun who turns towards him.

The middle-aged man profiled in the doorway stands on some steps. He turns towards his right but turns his head to his left, towards us, and looks out of the canvas in our direction. He makes a pointing gesture with his right hand in the direction of the two figures in the black frame and the man holding the paintbrush. Just above the head of the child, and off centre, are the two figures in a black frame, one male one female. They are shown three-quarter length. Above the head of the male is a bright red smudge and below his head is a blueish-grey smudge.

The pictures high up on the walls are large but do not show clearly what is on them. They are carefully arranged, and together with the door frame they form a precise geometrical arrangement. Everything shown appears to be very carefully arranged and placed. In contrast to the precise horizontals and verticals there are two unseen flowing lines which trace similar curves, one linking the heads of the artist and the five figures in the front row. The other links their hands.

The colour scheme is subdued, principally blacks and tans but it is sombre rather than cold. All of the principal figures share warm flesh tones and there are carefully placed accents of red: palette, flowers, ribbons, vase. Only the two three-quarter length figures in the frame have cold and greyish rather than warm flesh tones, but they are linked to the other figures by the red accents and the red smudge.

Over to you to respond with how much of that you do or do not see, and to add what you have seen and I have missed.

When I wrote that account I was not in the Prado looking at a framed painting. I was sitting at my desk looking at an image on my computer monitor. Conscience prompts me to admit that the image I was then looking at was very different to the reality of the painting itself. Somewhere along the line somebody would have taken a photograph of the painting and edited it, possibly by enhancing the colour, perhaps cropping the image. Of all the images of *Las Meninas* available on the internet I selected the one that seemed to me most faithful to my memory of the painting. Even so there is much that was important that the digital image could not show, and which I could not therefore describe. My monitor could not show the actual size of the painting or the texture of the paint and canvas, for example.

Even if we had been in the Prado looking at the painting itself, most of what I have described is, of course, an illusion. The only thing I would be able to see physically would be a piece of canvas with paint on it, in a frame. On that piece of canvas Velázquez cleverly created an illusion so convincing as to make me believe I could see the girl, the room, the artist, people. However, illusions are not reality. My point would be that most of the time I see only what I would like to see, or what convention has taught me to see. I doubt if anyone would say in front of Velázquez's *Las Meninas* 'the only thing I can see is a piece of canvas with paint on it in a frame' for fear of appearing stupid or perverse.

To my way of thinking, all art is about artifice and artificiality. I find that any art – be it a film, a play, a traditional painting or sculpture, or a conceptual art installation – whose principal ambition is to be a faithful transcription of reality, rapidly becomes tiresomely boring. For me,

true art is about escaping from the more tedious realities of my day-to-day existence into an imaginative realm of illusion and unreality. How mundane would be a life devoid of occasional make-believe. Picasso put his finger on it when he said 'we all know that art is not truth. Art is a lie that makes us realise truth. . . . The artist must know the manner whereby to convince others of the truthfulness of his lies'.

If we can come to some agreement about what we can or cannot see, let's see if we can also agree on who the people are and what they are doing. I will readily concur that they are all portraits, including a very rare, possibly one of only two, self-portrait of the artist Diego Velázquez. Everyone is a member of the court of Spain as it was in the mid-seventeenth century, the monarch being Philip IV. The only royal personage present for certain is the Spanish Princess the Infanta Margarita, who is the very young child in the white dress. All the other figures are courtiers of greater or lesser importance. That much I can see. Is the black-framed object on the far wall a mirror? If it is, does it show a physical reflection of the King and his wife, Mariana of Austria? If it does, it would presuppose that they must be standing more or less in the position of anyone looking at the picture.

If you follow this train of thought, Velázquez is presumably looking at them and painting a full-length double portrait of them. The Infanta Margarita has come into the room to watch her parents having their portrait painted or perhaps to ask them a question. For years I went along with this notion and did not question it. All the many claims to 'explain' the painting, or interpret it, and all the theoretical musings about the picture are based on this assumption. If you want to know how many there are, take a stiff drink before you look up *Las Meninas* on Wikipedia! It was only when I started to look at the

image day after day, week after week, month after month, admittedly on my computer monitor, that I began to doubt whether that was what was really happening. It would be very convenient if it was. *Las Meninas* could then be explained as though it were the solution to a difficult crossword puzzle clue. Having found the 'solution' or 'explained' it, we could then put it behind us, proceed to the next picture in the Prado, or turn the page in the book and continue on to the next chapter.

For me, these explanations have too many assumptions, too many 'ifs', too many 'what we see here is. . .'. The presence of the King and Queen may not be the physical presence that is presupposed by interpreting the object in the black frame as a mirror. Also, can I safely assume that what Velázquez is painting is a full-length double portrait of them? Did Velázquez do double portraits? Can you identify any other double portraits? And here is a real picky quibble. If it was such a portrait, it would presuppose a tall vertical canvas. As I can only see the edge of it, might it not be a horizontal canvas more suited to a group portrait or mythological picture? What if Velázquez is in the middle of painting a large group portrait with a long line of people (like a school team photograph), and he has asked the King and Queen for another sitting so that he can make some changes. These suggestions are a bit far-fetched, but not impossible. Sometimes the most unlikely version turns out to be correct. Like Sherlock Holmes, before I reach any final conclusion, I must have hard evidence. Holmes always carried a magnifying glass because he knew that the only reliable evidence was what he saw with his own eyes. There is no incontrovertible evidence that Velázquez is painting a double portrait of the King and Queen, or that they stand close to us as we jointly scrutinise the group of figures before us in the room.

This might be the moment to take stock of what we have seen. We might consider it a good opportunity to talk about what Velázquez was like as a personality and as a human being and fill in some of his biographical background. If you are very knowledgeable and carry a lot of cultural baggage, you might sigh and say that it is so difficult to get to know Velázquez because there are so few documents written by him (e.g. letters or diaries). Consequently it is impossible to get inside his mind. To which I would reply 'Rubbish! He left dozens of documents into which

he inserted his whole personality, his way of thinking and looking, and somewhere, in some of them, you may even find the imprint of his fingers. These documents are called "paintings".

Some of the best writings about art which show the greatest understanding of the artistry, the possibilities, the sensitivities, the hidden meanings, the true cultural context, the beauty, are by poets and writers of fiction – the W.H. Audens, the John Updikes or the Jeanette Wintersons of this world. Is it because they share common ground? A great painting or novel is a synthesis of reality and fiction, leavened by imagination. For me the best thing ever written about Velázquez is by the Spanish writer and philosopher José Ortega y Gasset. A connoisseur of life, and firmly in the liberal tradition, he knew all about Spain's troubled history for he was in middle age during the terrible years of the Spanish Civil War and chose to go into voluntary exile in Argentina. His brief essay on the artist is astonishingly short on facts but informed by a deep knowledge of his native country, its land, its people and its history, and by a profound wisdom about art and Velázquez. If you prefer knowledge and wisdom to information, it is necessary reading.

Learning how to compose a picture in terms of proportion and geometry was part and parcel of traditional studio training, and Velázquez is known to have possessed books on architecture and mathematics. The subject interested him, and he was an experimenter. I also believe that inherent in all the memorable Old Master paintings are structures, proportions, rhythms and mathematics, just as they are present in the great pieces of classical music and works of architecture. The human mind strives for order, and it is this fundamental – yet sometimes covert – order that causes these works to be retained in the memory and lends them their sense of 'rightness' and beauty. Until modernism changed the rules there were commonly used mathematical principles which are still readily recognisable. All this is easy to say, and relatively easy to find in the facade or floor plan of a building, or in a musical score. In paintings the structures and mathematics are often clandestine – perhaps deliberately so – and the rules less predetermined – but that does not mean that they are not there. *Las Meninas* has a very deliberate structure which I believe is one of the keys to interpreting its meaning.

It is not immediately apparent, and Velázquez's hidden geometry requires diagrams to show what he is up to.

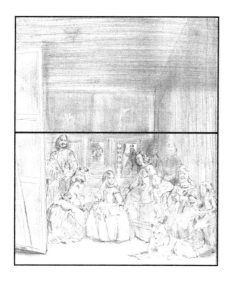

The painting is divided into two halves. Exactly halfway along the vertical is an unseen horizontal line, just above the head of the artist. It runs above the frame of the mirror and across the architrave of the door. It divides the canvas into an upper half and the lower part. It is not an approximation or guesswork. It is exact. All the human action is concentrated in the lower half, and the upper half is a vague shadowy space.

It is tempting next to draw the equivalent line vertically, down the middle, to see what happens. This line runs down the left-hand side of the door and the right-hand side of the face of the Infanta Margarita. (So far so good, but it shows that she is not placed exactly centre stage as one might at first glance suppose). Dividing the picture vertically into four equal sections is helpful, since this shows that what is centre stage is the group of the most intimate members of the Royal Family and Household (so perhaps the title by which the picture was habitually known, until the mid-nineteenth century, namely *La Familia* ['The Family'], was most perceptive). The artist and the other members of the court then fall neatly into, as it were, the two wings of a central secular 'altarpiece'.

If the picture is divided vertically into six equal sections, this division places in the first sixth, the artist's easel; in the second, Velázquez himself; in the third, the mirror (if it is a mirror), together with the Infanta and the first Maid of Honour; in the fourth, the open door with the Chamberlain and the second Maid of Honour; in the fifth, the mastiff and the shadowy court officials; in the sixth, more or less the two dwarfs.

Revelations can be made by identifying the triangles that are hidden in the combined geometry of vertical sixths and horizontal quarters. With these I believe I can see what a master Velázquez is, and how inventive is his handling of the geometry and mathematics. The inner triangle focusses attention on the little Infanta and the Spanish mastiff. To this is then added, through the next triangle, the most intimate members of her family and of the Royal Household. In the outer triangle are the less intimate members of the Royal Court, including Velázquez himself. It is a hierarchy which they would have recognised and respected.

The placing of the figures compositionally within this geometry is masterly, and the simplicity of the idea and its execution is, for me, utterly beautiful, as precise as a perfectly engineered piece of machinery. It took me hours of experimental line drawing and pondering to discover what Velázquez was up to. Maybe I am slow to spot the obvious, but for me the very elusiveness, yet at the same time the very rightness, of what he has done, and the lightness of touch with which he achieved it, continues to take my breath away. I wonder how long it took Velázquez to work out his scheme?

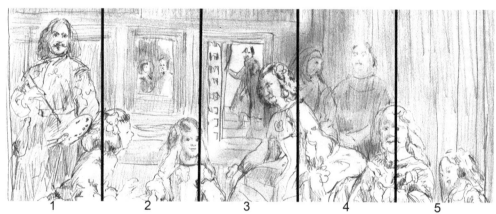

At the heart of the picture is the frieze of human faces, the portraits of the members of the Royal Family and Household, the participants in this scene, who together occupy scarcely a fifth of the entire canvas. Their placing is surely based on the geometry of six equal vertical sections (see below – the first sixth which has only the back of the canvas has been omitted).

Within this frieze there is, to my eye, the possibility of a further horizontal division which, in my poetic imagination, makes apparent a differentiation between those whose lives revolve around the Infanta, and those whose lives revolve around her parents, the King and Queen.

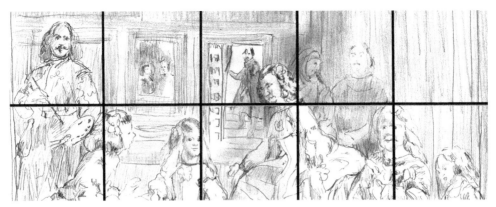

A true work of art has a life in the present as well as in the past, i.e. it is something that can be experienced in the here and now as well as being part of history. Is it right to look at paintings primarily as archaeological specimens to be analysed and then fitted into some historical, cultural or social theory? Or is one of the most important qualities of a work of art – arguably the principal quality – the personal aesthetic experience of it? I believe it is this continuing cultural and aesthetic relevance that differentiates a true work of art from a shard of ancient pottery or an antique frying pan.

All representational artists aspire to be conjurers. They seek, by sleight of hand, by dexterity and by perfecting the tricks of their trade to make us think that we see something that is not there, to believe that the block of marble is living flesh or that the dabs of coloured paint on canvas are, for example, a landscape with trees and sky. Most of the time, even if I am not fooled, I can enjoy the attempt and be entertained, especially if it is elegantly and pleasingly done, and if the work of art gives me the delight of recognition, or if it contains a message or narrative that I wish to hear. I can also enjoy the knowingness that comes from not actually being deceived by the conjurer, and the awareness that, although I cannot do that kind of trick myself, I at least have the knowledge and understanding of how it is done. Sometimes the conjuring trick is so accomplished that a significant part of the pleasure is not being able to work out how it is done.

On very rare occasions the artist is more than just a clever conjurer, but is a magician, a sorcerer, someone who can take a piece of lead and transform it into gold. Velázquez can command such magical powers – not in every painting, but in *Las Meninas* he proves without question that

he is one of the supreme sorcerers who can transform canvas and paint, not merely into an illusion of something else but into something which has an original life, and an existence of its own separate from anything else. When the painting is seen close to, my eye cannot but notice the individual brush strokes of coloured paint, the separate shapes of the areas of rich harmonious colours, and the skill with which they have been woven together. These then become transformed, at a distance, into light and shadow, tactile space, people, the real and unreal, past, present and future. It is a truly magical transmutation.

Most artists try to keep the moment of transmutation well hidden, determined that, however closely the painting is examined, you should not be able to detect the sleight of hand. Few succeed in this ambition. Velázquez, however, is the supreme tease. As I move my eye in and out he goads me into thinking that it must be possible to catch the moment that the threads of paint transmute, but the wily old sorcerer is too cunning, and it always proves impossible to catch that elusive moment when it happens. Also, he teases me by showing just enough places where there is sharp focus and precise detail – such as the edge of the canvas at the easel – and then others where the detail is so non-existent that it looks as though what is shown is in motion (such as his right hand). He keeps my eye in a constant state of baffled excitement, never quite sure what to expect next.

Equally breath-taking for me is the way he observes the light and shadow in that cool and gloomy room and recreates them in paint. Very few artists can catch the subtle experience of half-light or twilight. Velázquez could do it, as could Vermeer and as could some of the Danish artists of the late nineteenth century. It is so difficult to capture in paint because it depends upon the absolute and precise matching of tones. Colour, per se, does not come into it, for one of the beauties of half-light and twilight is the way they subtly soften colour to the point of disappearance. Yet, although tones begin to merge into one another, they never lose their individuality. It is as whispering is to the human voice, or pianissimo is to a musical instrument. How many actors can whisper softly yet make every syllable and consonant audible? Any actor can shout. Any pianist can go crash-bang on an instrument, but how few can play notes so

softly that they are almost inaudible, yet retain their clarity and precise relationship with each other? The ability to observe tones and match them on the palette without laborious trial and error is a precious gift. Only a few are born with it. Velázquez was, as was John Singer Sargent. Vermeer could do it although I suspect he had to work at it. David Hockney can go delightfully crash-bang with bright colour, but he does not have the gift of tone and atmosphere.

The light in *Las Meninas* seems to my eye to have its own physical presence as it explores and defines the spaces of that studio. It is critical for establishing the exact positioning of the figures. It investigates the textures and temperatures of their hands and faces, their hair, their garments and of course the dozing mastiff. If I look and listen long enough, on my own and in silence, I swear I can see and hear them breathe.

Looking is tiring, physically and mentally. Regular refreshment is essential. A lunch break somewhere outside the museum would give us an opportunity to clear our heads and provide an opportunity to discuss some of the broader contexts. For example, how much does Velázquez reveal about himself? I think he tells us as clearly and honestly as he can, in every square inch and brushstroke.

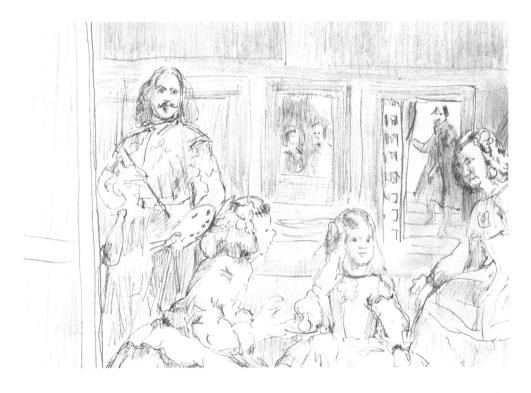

He is a member of the Royal Household, and it is clear from the way that he positions the figures and himself that he understands the rituals and priorities of court life. Ever present, he knows his place and hovers discreetly in the background. He is Principal Painter to the King. Of this he is proud, and it gives him special status at court. On his tunic is the Cross of Saint James of the Order of Santiago. That matters a great deal to him. When Velázquez was nearing the end of his life, Philip IV made him a nobleman by bestowing that order of chivalry on him. He is ambitious, but not egotistical. He shows himself in the act of painting a picture. What makes him tick is painting. Whatever other roles he may occupy in life or what other responsibilities he may take on, it is as a painter that he first wishes to be remembered. Painting gives him his greatest pleasure – you can tell that from the evident enjoyment with which he handles the materiality of his paints. It is the activity in which he can forget everything else and lose himself.

In this painting he is in late middle age, experienced, wise, discreet, silent. He is observant. Nothing much escapes his notice. He takes it all in and he thinks about it. Although he is aware of the grandeur and formality of the court and understands it, in the same way that he understands history and tradition and respects both, he prefers domesticity and informality. You can work that out from the very informality of this royal scene which is, however, not without grandeur. He is most at home, and most himself, in his studio. He wants it to be a place where other members of the court gather without formality to talk amongst themselves or with him, or be content to sit or stand in silence watching him at work. Even the royal animals will wander in and doze in this quiet atmosphere, a sure sign of its harmoniousness. The dog that dozes in the foreground is a Spanish mastiff, a breed noted for its intelligence, loyalty and protectiveness, by temperament inclined to be aloof, not very exciting or excitable, wary of strangers but patient with children, and willing to sacrifice its own life to protect that of its master or mistress. Like Velázquez, it is the perfect royal servant.

Although Velázquez knows his place, he is accustomed to being treated on equal terms by the royal family. Young and old are comfortable with him, and in private they do not demand distance from him. They trust him. He likes children and understands them. They fascinate him. He has experience of the knowing looks of little girls, of their self-consciousness and of the way they play games in which they pretend to be parents and adults, and of how they manipulate their fathers. He knows how small children like to please, and of how watchful they are of adults and the way they behave to each other. He delights in the way they are both innocent and knowing, and how you can read this in their faces and gestures.

He likes nuance and ambiguity, and although he is not interested in deceit or intrigue or trying to cheat you, he enjoys the way nothing is ever quite as it appears or what it seems to be. He wants to engage you and cause you to question what you see, not for moral or political reasons, but as a matter of actual perception. He prefers shadow and shade to the glare of bright light. He is aware of whispered conversations that go on in any community, and how people choose not to show their hand. He values the importance of ritual and hierarchy. He likes order, proportion and harmony. He is not afraid of silence or empty spaces. He likes to be respected. He is careful, meticulous, cautious, but not hidebound. He has imagination. He is sure of his own abilities and position and at ease in his own skin. He knows he is a supreme craftsman and the master of his art, yet he is aware he is growing weary, he no longer stands as upright as he once did, and that he probably is in the last chapter of his life. He wishes to leave behind a great painting by which he will be remembered in the years to come, a testament to what he is, what he is able to do and has achieved, and to ensure his place in the great scheme of things. Although he respects the opinions and pronouncements of others, he is entirely his own man, and is not judgemental.

You can read all the books written about Velázquez and they will not contradict any of this although they might add detail. For example, he was married, it seems happily. He had two children, girls, whom he loved. He came from a modest background and through luck and temperament as much as talent became one of the most close and trusted members of the court.

Although we have discovered much for ourselves simply by using our eyes, experience and intelligence, words and history are necessary to flesh out some factual details. Velázquez was 57 years old when he painted *Las Meninas* in 1656, with only four more years to live. It is a painting about, rather than of, the Spanish royal family as it existed in that year. The picture only acquired its now familiar name of *Las Meninas* ('The Maids of Honour') in the nineteenth century. It was given the name by the curators of the Museo del Prado in Madrid where it found its way shortly after the end of the Peninsular War, and where it has been ever since.

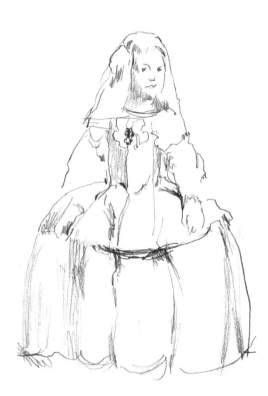

The centre of attention, the Infanta Margarita, was the daughter of the King, Philip IV, and his second wife Mariana. When the picture was painted, the Infanta Margarita had no living sibling other than an elder half-sister by her father's first wife. This sister, Maria-Theresa, was eighteen years old and destined to marry Louis XIV of France four years later in 1660. Velázquez would be the courtier responsible for organising the wedding ceremonies. Arranging such events was one of his official duties. This time it was to be his final court duty. The responsibilities and physical demands of this important occasion took such a toll on his ageing body and constitution that, having seen the ceremonies through to completion, he died shortly thereafter.

The little Infanta's great-great-grandfather was the Holy Roman Emperor Charles V who financed Magellan's attempt to sail westward round the world to find an alternative sea route to the all-important spice islands. He ruled over a vast European empire stretching from the Iberian

Peninsula in the west to Vienna in the east, from the Netherlands in the north to Sicily in the south. The burden of running this vast European realm and overseas empire with its constant squabbles, political strains, warfare and demands for territorial autonomy, together with the ideological conflicts between Catholics and Protestants, so exhausted him that in the end he gave it all up, abdicated and retired to the peace and quiet of a monastery in a remote area of Western Spain. He handed over the Holy Roman Empire (Germany and Austria) to his brother Ferdinand. To his son Philip he gave Spain, the Netherlands, his Italian possessions, and also his overseas empire – principally South America and the eponymous Philippines which Magellan had first discovered.

The Infanta Margarita's great-grandfather, Philip II, ruled this, the most powerful and rich kingdom in the world, for over 40 years. Melancholic, religiously devout, ascetic, he defeated the Turks, introduced the Inquisition and launched his disastrous failure of an Armada against the Protestant Queen Elizabeth of England.

Margarita's grandfather, Philip III, who reigned for over 20 years, was a pious but undistinguished monarch. His son, her father, came to the throne at the age of sixteen. Her family had a habit of interbreeding and dying prematurely. Consequently, much hung upon her health and survival. When *Las Meninas* was painted she was only five years old, blissfully unaware of the history and significance of her family's birthright, or that there was a distinct possibility that she herself could inherit it. The kingdom of Spain having no Salic Law, meant it was possible for a female to ascend the throne. The Salic Law of Succession was the rule by which in certain sovereign dynasties, notably France, anyone descending only through the female line from a previous sovereign was excluded from succession to the throne. That is why the French monarchy was an endless succession of Henris and Louis, whereas England has her Queens Elizabeth, Anne and Victoria. In 1665 the Infanta Margarita had no brothers, and only her half-sister, Maria-Theresa, stood between her and her huge inheritance.

What she could not know at the time was that this great inheritance was beginning to unravel. Her 51-year-old father knew it, as did Velázquez. Philip's new wife, Mariana, aged 22, was not interested in politics, and

probably did not fully realise the true significance of it all. Mariana was only four years older than Maria-Theresa, her stepdaughter. Mariana and Maria-Theresa were cousins and almost identical in looks. Philip IV was his wife's maternal uncle.

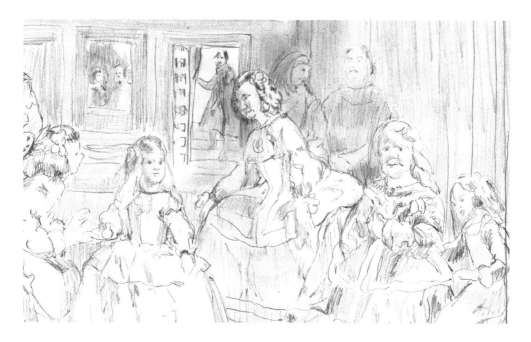

Do we need all this cultural baggage? It is a lot to take on board, let alone remember. It is, however, important. Less significant is the identity of the two young Maids of Honour who attend on the Infanta or of the group of figures on the right. The most interesting thing, for me, about the Maids of Honour is their gestures and attentiveness. I am a bee-keeper so I am most conscious of how they are shown as similarly attentive to the Infanta Margarita, like young bees to the queen in their hive. Without a fertile queen a beehive will die.

The two dwarfs, and the suggestion that one is German and female, one Italian and male, are footnotes to the main narrative, as are the identities of the two figures in the shadows in whispered conversation. They, like the dwarfs and the mastiff are part of the daily round of court life and set the scene. The figure in the doorway is Don José Nieto Velázquez (no relation), the Queen's Chamberlain. One of his main functions was to open and close doors for the Queen. He encapsulates the stifling formality and protocol of the royal court of Spain which was notorious

throughout Europe and drove even the future Charles I of England to distraction. So rigid was the ritual and etiquette that the King scarcely moved a muscle or even his lips in public, and in a reign of over four decades is said to have smiled in public only three times. Yet in private it seems he was quite humorous, enjoying sports and hunting, as well as the theatre.

Nobody knows how Velázquez intended *Las Meninas* to be seen or by whom. The room where he paints his picture had been the former principal chamber of the young Crown Prince Balthasar Carlos. After the Prince's death the King gave the room to Velázquez to use as a studio. This room was in the Alcázar Palace in Madrid – an ancient gloomy granite fortress on a promontory. Neither that palace nor the room now exist. Both were burned down in the early eighteenth century and were then replaced by a new splendidly over-the-top pleasure palace, the pride and joy of the recently installed French Bourbon dynasty who had replaced that of the House of Habsburg when their direct line of succession petered out. Many treasures and works of art were lost in the disastrous fire of 1734. The fact that *Las Meninas* was rescued when others were left to perish speaks of its perceived importance.

The painter and the monarch first encountered each other when Velázquez came to Madrid at the age of 23. They took an instant liking to each other. Philip IV, aged 17 and already wed, had been on the throne for barely a year. He had married his bride, Elisabeth of France, who was three years his senior, when he was ten. Although not unhappy with their respective situations they were never close. What had brought Velázquez to Madrid was his reputation as an extraordinarily skilful portrait painter. The King recognised this, and Velázquez was immediately appointed a Painter to the King, a remarkable achievement for one so young and completely unknown. The appointment brought a salary, a pension and accommodation, and in many ways Velázquez always regarded his principal career to be that of an office-holding courtier. Through loyalty, ability and perseverance he rose in the hierarchy to become Chamberlain of the Palace. The duties were onerous and time-consuming, and painting often had to take a back seat. The King gave him scarcely any specific commissions although a flow of

official portraits was expected. He was allowed exceptional freedom to paint what he wanted, when he wanted, how he wanted. *Las Meninas* was painted simply because Velázquez wanted to.

One of the great burdens for those who occupy high office is loneliness and boredom. Velázquez's studio provided a place where all could find momentary escape, and where even the monarch could relax. Portraits are rarely painted in total silence. They must have talked. Philip liked to watch Velázquez at work. Philip was not a heroic character. On a rare occasion when Velázquez expressed a personal opinion (other than in paint) he said 'he [the King] mistrusts himself and defers to others too much'. When Philip heard that Velázquez had died, he is said to have shed tears.

After Philip IV died *Las Meninas* was probably left quietly somewhere out of the way, not much visited or looked at. Today, as one of the crowning glories of the Museo del Prado in Madrid, it is seen by thousands of pairs of eyes every single day. Would Velázquez be pleased, puzzled or horrified? He might be pleased by the reverence shown to him as an artist, but I suspect he would be disappointed that although so many thousands line up to see his painting, scarcely one of them actually looks at it.

In my view the proper way to present *Las Meninas* is nothing like the current celebrity, but chilly, display in the Prado. If the painting were mine to do with what I liked, I would display it in the Drawing Room (now called the Oak Room) at Broughton Castle. It is a room which I know well, being both a memory embedded in my childhood and in a location not far from where I now live. I can envision daylight, preferably subdued evening light, slanting indirectly from the right-hand side and the painting placed not too high off the ground. Velázquez's studio in the Alcázar Palace was not dissimilar in size and lighting to the Drawing Room at Broughton Castle. Both castles underwent major modernisation at the same time – the mid-1500s – which is when the Drawing Room and the room which became Velázquez's studio were added.

I would try to create a continuum in space and light between my room and that of the painting itself, so that their shadows and dark corners

would seem to merge imperceptibly into each other, and the light in the painting would seem to be the natural consequence of the light that comes into that room. It is not difficult to imagine Philip IV returning to Velázquez's studio after the death of the painter, sitting alone on a chair in front of the painting, with the image and memory of the man who had been his closest and possibly only true friend for over three decades, before his eyes, supposing him still to be alive. In the setting of Broughton Castle, I think that I too, like Philip IV, might have the illusion that everyone in the painting were alive, in front of me.

Finally, we might discuss how each of us might now interpret *Las Meninas*. Here is my interpretation which you are free to go along with in whole or in part or reject entirely as completely misplaced.

Many other times I have asked myself, 'Why can I not see what Velázquez is painting?' I can only offer my own slant, which is an amalgamation of fact, fantasy, speculation and imagination, and which I have not come across anywhere else.

Without splitting hairs, Velázquez only painted one group portrait, and this is it. All his other portraits are of single individuals. Maybe, as he neared the end of his days, he thought he would like to paint a group portrait of the family with whom he had spent most of his life. Perhaps the King himself requested it or hinted that he should try it. Paradoxically, however, that was where Velázquez's dilemma began. Who should be included? What about the 'absent friends'. It is a picture that is as much about who is not there, yet who ought to be there, as about who is there.

I also like to speculate whether the canvas he is working on – of which I can see only the back – is at a very early stage, or nearly finished, or whether it may not be a portrait at all. Perhaps he is painting one of his mythological scenes, and that is what the Infanta Margarita has come to see? All these things, even if unlikely, are possible. There is no 'truth' that can be proved one way or the other. What he does, which is what all great artists do, is open the door to a world of almost unlimited imaginative possibilities.

In the year that *Las Meninas* was painted the royal family consisted of the King and Queen and their only child, the five-year-old Infanta Margarita, plus, most importantly, the only surviving child of the King's first marriage, the teenage Maria-Theresa. Should she be included or not?

Given my own family history, I feel Velázquez's dilemma rather keenly, and I suspect he was in a quandary seasoned with anguish. My hunch is that as he looked at Philip IV, his friend, and reflected on all the sorrows he had had to cope with, and as he pondered all the 'what ifs' that had beset the life of the monarch, he realised that he could not bring himself to paint a straightforward group portrait. He knew, in his heart of hearts, that the end result would not be the picture that he ought to be painting. If those 'what ifs' had been in the monarch's favour, if all the cards had gone for him rather than against him, how different would be this royal family and their kingdom; and how different might have been the fate and future of Velázquez himself?

The Queen ought not to be the plain and awkward Austrian Mariana, young enough to be Philip IV's daughter, but his first wife, the beautiful,

intelligent and accomplished French Princess, Elisabeth, whose mother was Marie de Medici. Older than Philip, she gave birth to eight children. Only two survived beyond infancy, and then she herself tragically died at the age of 41. It seems she did not care for Velázquez, and in the complex world of court politics suspected – probably wrongly – that he was not on her side. Her untimely death probably strengthened the friendship between Philip and Velázquez.

It should have been a group portrait of the first royal family and their many children. Centre stage would have been their only son Balthasar Carlos, handsome, healthy, intelligent and able, who would now be 27 years old. Destined to succeed his father, it had been arranged for him to make a strategic political marriage to the Habsburg Archduchess Mariana. Then fate dealt a cruel blow. Two years after the death of his mother, Balthasar Carlos contracted smallpox, and in 1646, at the age of 17, he died. His death broke his father's heart and threw the royal family and Spain into yet more turmoil. Not only was there now no male heir: there was no concluded political alliance that would benefit ailing Spain. There was also a teenage Habsburg Archduchess without a marriage partner. A solution was required. Within weeks the middle-aged widowed father became betrothed to his dead son's teenage fiancée, and they were married three years later. Now, as Velázquez contemplates his painting to be, they have a five-year-old child; but it is not a son, and the possibility of a male heir is as remote as ever.

How could any painter who knew this family so intimately (for Velázquez had lived with them day by day for over 30 years) possibly paint a picture that could begin to tell the story of their lives? No wonder half the canvas is a shadowy space. It is as though, in that dimly lit space with its insubstantial ghostly presences, there hover all the dreams, hopes and aspirations that were never to happen. No wonder that the image of the King and Queen side-by-side in a black frame is shadowy, for theirs was not a marriage that was ever supposed to have been. Perhaps the shadowy male image is meant to suggest the presence of 27-year-old Balthasar Carlos and the marriage that should have been, but which never occurred? That empty space in the top half of the canvas symbolises, in my mind, the tragedies and sadnesses that were the lot of this most unfortunate of royal families.

What Velázquez created, to my mind with such breath-taking enigmatic brilliance, is one of the few truly epic paintings ever made. In it the tragic story of the life and times of one of Europe's great ruling families is not so much revealed as alluded to with the greatest humanity and wisdom. Through the most subtle hints and clues he invites us to understand them and to show compassion. Most lives, however exalted or humble, are part of a pattern of the unpredictable, sometimes cruel mysteries of life and death. Many of us, in retrospect, reflect on the 'what ifs'. The truth is that at the very moment we come into the world, and at the very moment we leave it, we are all the same without distinction or hierarchy, and what happens between those two events is largely the outcome of the accidents of birth and fate, together with the proverbial roll of the dice. That, for me, is what Velázquez's picture is about.

It is not possible, today, to paint an epic picture like *Las Meninas*. The nature and purpose of picture making has changed. In Velázquez's

day it was possible to explore multiple themes and images within a single picture and so embrace, like a self-contained piece of theatre, the narrative sweep of a monumental human drama. Such themes then became the turn of the novel and opera. Nowadays such epic narratives belong to the cinema or television. There is a wonderful film to be made about Velázquez and the family of Philip IV. How he spent his life with them, and how at the end of his days when challenged by the idea of painting the royal family together with all that he knew about them, he despaired, yet finally came up with an extraordinary and utterly brilliant solution. That is why no one can see what is on the canvas that he is painting. It is a gift of a story line that comes complete with flashbacks and moral dilemmas, itching to be told with cinematography inspired by the atmospheric grandeur of Velázquez's paintings. I have a feeling that such a film would thrill Velázquez rather more than the current lifeless display in the Prado.

Painterly Reflections by Gino - Velázquez

Creating atmosphere is everything for Velázquez. He uses light and shade to captivate the viewer and explain how he sees the world. The marks that he makes with his brush with such lightness and freedom simultaneously sustain this atmosphere and demonstrate the ephemeral nature of both the art of painting and that of human existence. For Velázquez, human beings are not gods, nor are they cyphers who merely display only the outward appearances of humanity.

Velázquez transports us to a key moment in his life. He is an artist who has earned high status, yet he proudly shows himself with just the simple tools of his trade: paint, palette, brushes, easel and canvas. Although he has been embraced by a world of utmost privilege, that of the Spanish royal family and its close inner circle, he chooses to show an intimate self-portrait of himself, surrounded only by those he lives with day by day. Even so, he alludes to their obedience to hierarchy, to covert expressions of power, and to moments of formality or informal humour. He gives order and weight to his observations through his organisation of perspective, or the way he modulates atmosphere, or the manner in which he uses light and shade to create visual and symbolic emphasis and contrast.

The brightest light shines on the five-year-old Infanta, whilst in the distant, half lit framed mirror, the images of the King and Queen look on pensively. In the doorway, at one of Velazquez's perspectival vanishing points, stands the Queen's Chamberlain. Caught between entering and leaving, he suggests the uncertainties present in this fragile house of cards.

I first encountered Velázquez at the National Gallery in London. The paintings in the Gallery spoke with a clarity in which words had no real place. I found Velazquez's use of paint to be both familiar and liberating, as was his ability to hold multiple realities without the need for a ubiquitous descriptive label. It was the moment I knew I wanted to be an artist. I learned much over the next few months as I worked

on making drawings of the great paintings in the Gallery. My aim was not to copy, but to look at the deeper meaning implied by the artist in combination with the techniques used.

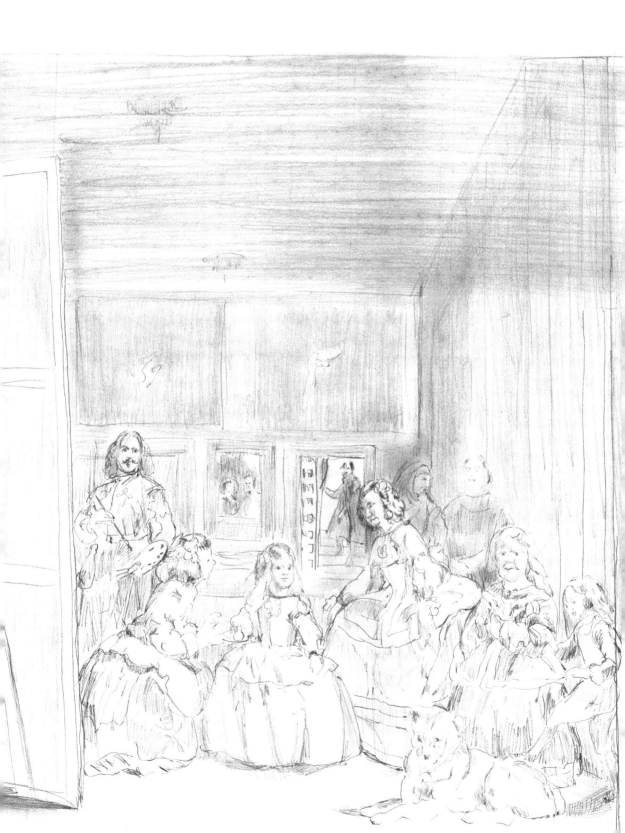

The Cortona Altarpiece
by Fra Angelico of the
Annunciation is in the
Museo Diocesano,
Cortona

After Fra Angelico
pencil on
watercolour paper

Fra Angelico
The Cortona Alterpiece

Fra Angelico

The Cortona Altarpiece

If we have established a good rapport during our visits to the Prado and decide to get together again (as I hope we will), may I suggest that we next meet in Italy, in Tuscany, in Cortona?

As I am sure you will have realised, my three summers in Cortona were a turning point in my life, literally a renaissance, a rebirth. It has become something of a cliché for the young from northern Europe, accustomed to grey light and short winter days, to find life transformed by a first visit to the shores of the Mediterranean. Matisse, who was born and brought up near Flanders, was in his late 20s when he made his first such visit, and it changed the course of his art and life. Goethe was in his mid-30s when he first crossed the Alps, full of hope and expectation. He was so taken with the benign climate and fertile landscapes of Italy, finding humankind and nature to be in such harmony, that he returned home to Weimar with the greatest reluctance. The Napoleonic Wars prevented J.M.W. Turner from visiting Italy until he was in his early 40s but the experience was a revelation – never had he seen light and colour of such intensity. As a consequence he began to change his palette and the way he painted gradually became much looser, so that some people thought he had taken leave of his senses.

The reason for our visit is to see *The Cortona Altarpiece* by Fra Angelico. It is one of the gems of the early Renaissance and painted on the spot in Cortona for the church of San Domenico. It is still in the town, although modern standards of conservation and security mean that it is no longer in a church but in the Museo Civico where it is admirably

and sensitively displayed. The main panel shows *The Annunciation*, and under it five predella panels illustrate the supplementary scenes from the *Life of the Virgin*. It still has the original tabernacle frame – it is the earliest surviving example of such a frame – and the whole altarpiece is intact. Regrettably most were broken up in the nineteenth century when the religious institutions that had commissioned them were dissolved. The various components were then sold on the art market to private collectors. Today, most of those parts can be seen dispersed around museums internationally but their original purpose and context are lost. A complete and entire altarpiece of such quality, still in the place where it was created, is very rare.

Before we go to the Museo Civico and start exercising our eyes, I would like to have a wander round the town together to talk about life in Italy, the Tuscan temperament, and to recall what we might both remember about Fra Angelico. Afterwards I suggest we enjoy a glass of wine and a

light lunch in the main square of Cortona. We should then aim to spend a couple of hours or so looking at *The Cortona Altarpiece* in the afternoon, and in the evening we might muse on what we have absorbed during the day over a decent dinner with local specialities.

Cortona is one of the most ancient cities in Italy, founded long before the Romans, and once part of the Etruscan federation. The Etruscans were an urban people, and the high point of their civilisation was in the sixth century BC. Their heartland covered modern Tuscany. Cortona was subjugated by the Romans, and Hannibal laid waste to their fertile land the surrounding valley. I doubt if the higgledy-piggledy layout of narrow streets in the centre of the town inside the mediaeval walls has changed much since Fra Angelico resided there. During our walk I would like to go to the highest point to show you a bird's eye glimpse of the little church of Santa Maria del Calcinaio tucked in at the side of the winding road that leads up from the plain to Cortona, and to share a splendid panoramic view over the Val di Chiana with a glimpse of Lake Trasimeno in the far distance.

The centre of Cortona is rather short of memorable examples of pure Renaissance architecture – most of the buildings are Etruscan in origin with later alterations and additions. Santa Maria del Calcinaio is a small gem of Renaissance proportion and perspective, a perfect example of 'Man the Measure of All Things'. Although it postdates Fra Angelico's stay in Cortona by half a century, the painter was one of the first to experiment with perspective in paintings and knew all about the new Renaissance architecture with its mathematically calculated curves, human proportions and classical references, ambitiously innovative in its aims and superseding the soaring pointed arches and superhuman scale of the Gothic.

To get to the summit of the town we should walk up the precipitously steep via Berrettini so that I can point out number 37 which is where I spent two summers. I also want to make you puff. Even when we were young it was hard work climbing that steep street with weighty shopping bags. On market days it was a quick and easy walk down the street to the centre of town, under an archway and into the Piazza Repubblica or the adjoining Piazza Signorelli, to spend our precious

communal money or have a drink in one of the surrounding cafés and bars. So it is there that I shall propose we pause for our glass of wine and bite to eat. We should choose to sit out in the open air so that we can watch the world go by, be entertained by the traders and customers doing their business if it is a market day, and pass judgement on whom we see.

The Piazza is the centre of Italian life, as much so today as it was in Fra Angelico's time. It is around the Piazza that civic and ecclesiastical buildings are ranged, and they sit happily alongside the shops, bars and cafés. The benign climate encourages the Tuscans to live their lives out of doors, and they are a people with great visual awareness. Elegant,

with fine faces and graceful movements, they like to look and be seen. As we watch them pass by, we might catch glimpses of faces that seem to have stepped straight out of a Botticelli or a Fra Angelico.

All Italians like to keep up appearances and dress elegantly – and have the knack of doing so on a shoestring. Tuscans also enjoy calculating. They will look you up and down and assess you, especially if you are a stranger. That is what the evening passeggiata is all about – the leisurely stroll around the Piazza to acknowledge friends, plot against enemies or weigh up new arrivals. They are commercially shrewd. The stallholders in the Cortona market know exactly what the commodities they are selling should be priced at, as do the customers, and if their expectations do not tally there will be intense haggling. I will also ask you to notice how, if a banknote is handed over in payment and coins are given in exchange, they are carefully examined in the palm of the hand to make sure that the adding up has been correct. Also important is good design, whether it is a building, a piece of furniture, a pair of shoes, a suit or a skirt. The best design depends on the right proportion, mathematical calculation, precision of measurement and cut, and meticulous craftsmanship and finish. It is not surprising, therefore, that many of the world's greatest fashion houses have a Tuscan origin. In the Cortona marketplace we, as visitors, will be able to see plainly how men and women are still the 'measure of all things'. That, for me, is one of the joys of Italy.

Whether you agree or not, I am conscious that what I have just expressed is influenced by what I have gleaned about Fra Angelico's life and personality. Not much is known about him for certain. A native Florentine, his date of birth at the end of the fourteenth century or early in the fifteenth is obscure. He died in 1455, probably in his 60s or 70s, and was probably in his late 20s or early 30s when he lived in Cortona. He obviously had extraordinary natural talent. He liked clarity, order, detail, purity, anecdote, possessed a profound Christian faith, and was well versed in the Scriptures and religious symbolism. Rather than make his way in the world as a journeyman painter he chose instead to become a Dominican friar and devote his life to the worship of God. His art was his manifestation of this devotion.

The Dominican Order was founded in the early thirteenth century to preach the gospel and to oppose heresy. The focus of the Order was to be scholarship and teaching, and it was at the forefront of intellectual life in the Middle Ages. Dominicans have a conviction that a belief in God and the Christian faith is rational, perfecting the human person and completing the fundamental human desire for truth and goodness. Strict and demanding, Dominican clergy earned the nickname 'Domini Canes (The Hounds of the Lord)' as they were perceived by their 'barking' to be acting as guard dogs against deviations from God's word of salvation.

Before he turned to the painting of altarpieces and ecclesiastical mural decorations Fra Angelico mastered the art of the illuminated manuscript. It is clear beyond doubt that, even in his own day, he was considered to be an utterly blameless, sweet-natured, pious and wholly admirable human being. Born in Fiesole just outside Florence, he was called Guido di Pietro. When he became a monk he was known as Fra Giovanni da Fiesole. He was referred to, even in his lifetime, as Beato Angelico – 'Blessed Angelico'. He was officially canonised by Pope John Paul II in 1994. He was a dyed-in-the-wool Tuscan: practical, shrewd, alert, precise, careful, manually skilled, interested in intellectual matters, conscious of human and man-made (as well as natural) beauty, well read, observant, curious, attracted by innovation and modernity yet never losing sight of the importance of tradition and history. We will, I think, be able to confirm this assessment in every square inch of *The Cortona Altarpiece*.

Over lunch I would like to ask: How well do you know the New Testament? Do you know the biblical account of the *Adoration of the Magi?* Do you know any other tellings of the same story? Would you know in which gospel to find the account of the visit of the Archangel Gabriel to the Virgin whose name was Mary? If you do, would you be able to recite the thirteen verses from memory? It does not matter if you cannot. My point is simply that when we are in front of *The Cortona Altarpiece* we need to have those exact words from the Bible in mind. Forewarned and forearmed I have them in my pocket on a piece of paper.

It is a short walk from the café in the Piazza to the Museo Civico. As we make our way you might well ask my reasons for choosing *The Cortona Altarpiece*. Although its Christian and spiritual content is not unimportant to me, I chose it principally because it is everything that the Velázquez is not. *Las Meninas* comes entirely out of the artist's own imagination. *The Cortona Altarpiece* depends entirely on a pre-existing written narrative. *Las Meninas* is rich with ambiguity, reflections, memories, sadness, mortality, inflexibility, tradition, shadows and half-light. *The Cortona Altarpiece* thrives on precision, clarity, brightness, innovation, birth, newness and joy. Aesthetic pleasure is very often stimulated by the juxtaposition of contrasts. Chefs know how to place sweet against sour or use a silky texture as a foil to crunchiness. Winemakers know how important it is to balance sweetness and acidity. Painters know how to heighten a feeling of warmth generated by an area of red by introducing an adjacent detail with a cool blue. Knowledgeable architects are well aware of the enhanced impact of a curve when set amongst straight lines. Sculptors will mix polished smoothness and chiselled roughness. Musicians will play hide and seek with fortissimo and pianissimo.

There is nowhere to sit in front of *The Cortona Altarpiece*. Instead, it is displayed at a height that presupposes an altar beneath it, and the clever curators have provided an altar rail so that the visitor can kneel when contemplating it. This is not necessarily an invitation to show Christian

devotion. Rather it is a recognition of how the *Altarpiece* was intended to be displayed and looked at. It is only from a kneeling position that the spiritual significance and spatial perspective of this truly remarkable work of art can be properly seen and understood.

From the altar rail the first things that are noticeable, because they are at eye level, are the predella panels with the scenes that narrate incidents from the *Life of the Virgin*. The spatial arrangements in each presuppose that

the kneeling worshipper is an unseen participant at the edge of each event witnessing the action taking place. The visit of Archangel Gabriel to Mary and the conception of Jesus is the most important event in the *Life of the Virgin*, but it is not an event that could have been participated in by any mortal witness. This is the subject of the main panel of *The Cortona Altarpiece*. However, before we discuss this principal feature and the spiritual message of *The Annunciation*, perhaps we should first look in detail at the predella panels.

 At the foot of the left-hand pilaster is a simple and straightforward representation of the birth of the Virgin. Under the right-hand pilaster is a similar sized panel which shows St Dominic receiving from the Virgin the black-and-white habit by which all future Dominicans would be readily identifiable.

Each of the oblong predella panels is roughly six inches by twelve inches. Reading from left to right: the first shows *The Marriage of the Virgin* to Joseph, taking place in the open air against a background of early Renaissance architecture and a gathering of animated young faces and trumpeters. It is a celebration of a joyous event without any attempt at historical accuracy or reality.

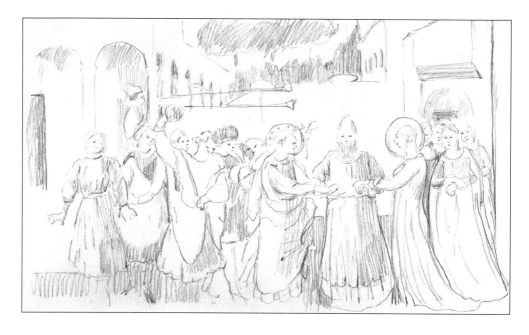

In the second panel Fra Angelico illustrates *The Visitation*, the occasion when the Virgin Mary, already pregnant, visits her cousin Elisabeth. Although St Luke describes how Mary went 'into the hill country. . . into a city of Judah', Fra Angelico places the scene in the Tuscan hills. In the background can be seen unmistakably and identifiably, the Lake of Trasimeno with the little town of Castiglione del Lago nestling by its shore as it still does today. Mary is followed by a handmaid who puffs wearily up the hill with a heavy bag, just as we often did after shopping in the market.

The third panel shows *The Adoration of the Magi*. If the predella panel of *The Visitation* is a delightful exercise in poetic reality, *The Adoration of the Magi* is an exquisite exercise in poetic unreality, with all the fresh innocence of a primary school nativity play. Fra Angelico creates a stage set where the centre of attention is the child and his parents. The Holy Family is truly blessed, kings wear crowns and regal garments, everyone looks happy and un-careworn, the attendants look like classmates in their party clothes. The stable and the towered landscape look as though

made from toy building bricks nestling in scrunched up brown paper. The white horse and the ass which peep in surreptitiously, might have come from a miniature farm.

The fourth panel shows *The Presentation of Christ in the Temple*. According to the gospel, Mary and Joseph took the Infant Jesus to the Temple in Jerusalem 40 days after His birth to complete Mary's ritual purification after childbirth and to perform the redemption of the firstborn son, in obedience to the Scriptures. Fra Angelico uses it as a good excuse to indulge in some mathematically correct linear perspective, and he has a good eye for innovative Renaissance architecture with delicate and refined details.

The last panel shows *The Burial of the Virgin*. Mary lived to a good old age, and she is supposed to have been buried in the Valley of Cedron near Jerusalem. Fra Angelico creates an arid landscape far removed from the fertile plain of the Val di Chiana. Legend states that Mary had a peaceful and painless death more like a descent into sleep, and that her soul was reunited with her son whereupon it ascended triumphantly into heaven. Christ is present, gently caressing a baby which is a symbolic representation of the soul of his mother. St John the Evangelist holds a palm. A palm branch, a symbol of victory over death, was supposed to have been carried by the Angel Gabriel when he visited Mary, and palms were waved by the welcoming crowd who rejoiced at Jesus' triumphal entry into Jerusalem before they turned against Him and demanded His trial and crucifixion.

All of the scenes of the *Life of the Virgin* show events that happened on earth and at which anyone kneeling at the altar rail could theoretically have been present. By placing them in an up-to-date Tuscan setting or recognisable local landscape Fra Angelico invites the Christian worshippers of Cortona to suspend disbelief and imagine that these events happened in their town, in their lifetime.

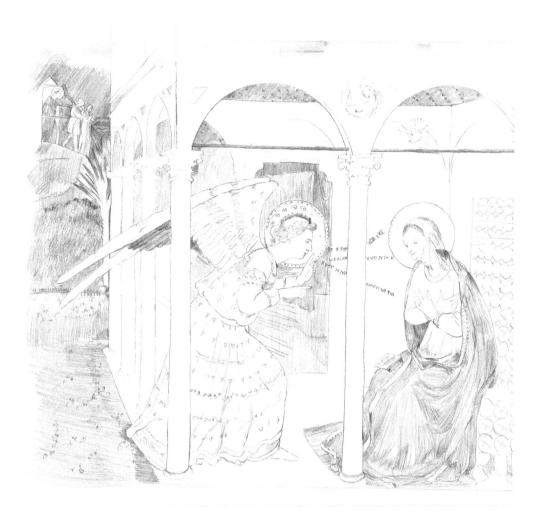

The Cortona Altarpiece is a consciously didactic work of art. The main panel showing *The Annunciation* is a visual sermon by a young Dominican friar to the faithful of Cortona, explaining to them the true meaning of Saint Luke Chapter 1, verses 26 to 38, and asking them to understand the significance in their own lives of God's goodness and grace.

The Annunciation is placed above the predella panels and is therefore structured to be looked up at from below. All Renaissance altarpieces are structured around a spiritual hierarchy, and from a kneeling position the hierarchy is visually manifest. On the lowest level (in this instance the predella panels) are mortal human beings. Above them spiritually and spatially you might expect to find mortals touched with holiness such as the Virgin Mary and the saints. Above them will be the first level of immortals, such as angels and archangels, cherubim and seraphim.

Above them, and above everything will be the Deity, God the Father, the Son and the Holy Ghost.

All life on earth commences with a moment of conception and a birth and ends with a death. For most lives, birth may be more consequential than death. The most important event in the life of Jesus Christ is not His birth but His Crucifixion and Resurrection. Christ died to redeem the sins of the world. He suffered and was buried. He rose from the dead. That is why Easter is the most important event in the Christian calendar. Modern secular society, which shies away from any mention of sin and death, responds more willingly to Christmas which is easier to promote commercially.

In this main panel, Fra Angelico has consciously used perspective to draw the eye along the carefully delineated lines of the floor into the heart of his depiction of *The Annunciation*. As well as appreciating his excitement at the new techniques of geometric perspective and his delight in figuring out and calculating the correct mathematical angles, we should also enjoy the places where the perspective goes slightly wrong because he has not completely mastered how to do it. However, Fra Angelico's use of mathematical perspective was not a matter of cold, unemotional accuracy. I think he also realised that by drawing the eye into the spatial centre of this other-worldly scene he could encourage the spiritual participation that was, for him, at the very heart of *The Annunciation*.

What, then, is the true meaning of *The Annunciation* as expounded by Fra Angelico? He takes us through the relevant passage in St Luke's Gospel verse by verse:

> 26 And in the sixth month the angel Gabriel was sent from God unto a city of Galilee, named Nazareth,

> 27 To a virgin espoused to a man whose name was Joseph, of the house of David; and the virgin's name was Mary.

The 'sixth month' is not month six in the calendar, i.e. June. It refers to Mary's cousin Elisabeth and the sixth month of her pregnancy. When Mary visited her (*The Visitation*) she did so because Elisabeth was about

to pop. Elisabeth and her husband Zacharias were elderly and believed they could not have children. Elisabeth's pregnancy was, therefore, a miracle, a gift from God.

> 36 And, behold, thy cousin Elisabeth, she hath also conceived a son in her old age: and this is the sixth month with her, who was called barren.

> 37 For with God nothing shall be impossible

Tradition has it that before the Angel appeared, Mary had been sitting quietly on her own, reading the Bible and specifically the Old Testament (the New Testament did not yet exist), Isaiah Chapter 7, verse 14: 'Behold, a virgin shall conceive and bear a son, and shall call his name Immanuel'.

> 28 And the angel came in unto her, and said, Hail, thou that art highly favoured, the Lord is with thee: blessed art thou among women.

> 29 And when she saw him, she was troubled at his saying, and cast in her mind what manner of salutation this should be.

Gabriel radiates energy and certainty as he looks at Mary eyeball to eyeball, and points with both his right and left forefinger to ensure that his message will get across and not be misunderstood. He is on

a mission. He is not given to self-doubt, and he is in a hurry. The Virgin Mary looks up from her book. Although she is surprised – 'troubled' – Fra Angelico chooses to portray her as showing no anxiety or lack of confidence, although she must have made a sudden move as the book she had been reading is about to slip off her right thigh. She meets the Archangel's gaze with equal directness. This is the moment she has been waiting for. She is ready. Indeed, Fra Angelico has

placed a wedding ring on her finger. Nonetheless, though they are close to each other physically, Fra Angelico is at pains to point out that they are not in the same realm. The Archangel Gabriel is in the space of the loggia but separated from the Virgin Mary by the column between them – an indication of the necessary separation, but not alienation, between the Earthly and the Divine

> 30 And the angel said unto her, Fear not, Mary: for thou hast found favour with God.

> 31 And, behold, thou shalt conceive in thy womb, and bring forth a son, and shalt call his name Jesus.

> 32 He shall be great, and shall be called the Son of the Highest: and the Lord God shall give unto him the throne of his father David:

> 33 And he shall reign over the house of Jacob for ever; and of his kingdom there shall be no end.

In turning the words of St Luke into imagery Fra Angelico, like any other artist, faces a number of problems. As far as I am aware no mortal has ever had a physical sighting of an angel. Then if that is so, Fra Angelico's Archangel must be wholly imaginary. Nevertheless I find that he has painted the Angel Gabriel with complete conviction. The precise details of the costume, the wings and the carefully coiffed golden hair are almost enough to make me believe that Fra Angelico might have seen an archangel. The only occasion when I have seen a figure with wings to compare was in Sicily, on a fifth-century BC red-figure Attic (Greek) vase, which included an image of Eros (the Greek

god of love) with long vibrant feathery wings and youthful verve that could give this Archangel Gabriel a run for his money.

Turning an exchange of words into images presents another problem.

> 34 Then said Mary unto the angel, How shall this be, seeing I know not a man?

> 35 And the angel answered and said unto her, The Holy Ghost shall come upon thee, and the power of the Highest shall overshadow thee: therefore also that holy thing which shall be born of thee shall be called the Son of God.

> 38 And Mary said, Behold the handmaid of the Lord; be it unto me according to thy word. And the angel departed from her.

Fra Angelico's solution is ingenious and in the circumstances probably as good as can be. He includes the actual words that pass backwards and forwards and writes them in gold, in Latin. They are partly abbreviated and partly hidden behind the column. The Archangel Gabriel says (verse 35): 'SPIRITUS SANCTUS SUPERVENIET IN TE, ET VIRTUS ALTISSIMI OBUMBRABIT TIBI'. The Virgin Mary replies (verse 38): 'ECCE ANCILLA DOMINI: FIAT MIHI SECUNDUM VERBUM TUUM'.

His words, which read from left to right, bisect hers. Mary's words, which necessarily read from right to left, are written upside down so that they come directly out of her mouth as a coherent readable sentence. Only the Devil speaks backwards. For anyone unable to read it must have been abundantly clear that they are speaking to each other, have something specific and important to say, something so momentous that it has to be spelled out in letters of gold.

The Angel Gabriel points with his right finger at Mary, who covers her breasts and heart with her hands. I think it possible to see a physical connection and ardour between these two young people. Their direct gaze and flushed cheeks suggest intense passion. With his other hand the Angel Gabriel points upwards to the dove which radiates light like the sun, and which has a halo of gold, circled with red. Thus, the dove of the Holy Ghost, floating like a divine soap bubble, slowly

descends towards Mary. This is the precise moment of conception of Jesus Christ, i.e. the union between the Earthly and the Divine.

Blessed with one of the best brains of his generation, Fra Angelico, like his fellow Tuscans, was insatiably curious and inventive. He was interested not just in the science and art of painting, but in architecture, Antiquity, literature, poetry, symbolism, nature, human anatomy, the relationship between God and mankind, and humanity's place in the universe.

In *The Cortona Altarpiece* Fra Angelico demonstrates the extent and depth of his learning, notably in the several places where he plays with metaphor and allegory. This would have pleased many of his fellow Tuscans, but he always wore his learning lightly and always made sure that the symbolism he employed was as pleasing to the eye as to the intellect. The garden is a perfect example. The dark and lush green lawn is a visual delight, dotted with tufts of spring flowers, daisies especially. Everything is painted with the skilled hand of one who had trained as a miniaturist. The Annunciation occurred in springtime, the Feast of the Annunciation in the Church calendar is 25 March, and in fifteenth-century Florence the official celebration of the New Year, both civil and religious, fell on that day, which is more or less the time of the Spring Equinox.

In the garden Fra Angelico has placed the shrine-like building in which the Annunciation takes place. Around the garden is a little wooden paling fence separating it from the world beyond. An enclosed garden – *the hortus conclusus* – is a symbolic reference to Mary's virginity. The expression *hortus conclusus* is derived from the late-fourth-century Latin translation of the Bible where in the Song of Songs or Song of Solomon (the fifth Book of Wisdom in the Old Testament) there is a reference to 'a garden enclosed is my sister, my spouse; a garden enclosed, a fountain sealed up'. On the fence-line two red carnations sit between two white roses (symbols of purity) and white carnations (which symbolise love). According to Christian legend when Jesus carried the Cross, the Virgin Mary shed tears at His suffering, and red carnations grew where her tears fell.

There is a pomegranate tree behind the fence and a pomegranate hedge partially covers it, both bearing fruit at different stages of ripening. The pomegranate fruit is deeply symbolic. The size of a tennis ball, it has a hard outer case and is stuffed with seeds. It symbolises the Resurrection (the seeds will regenerate); chastity (well protected seeds); and the unity of the Church (many seeds inside one secure container). The Archangel Gabriel's wings dip into these pomegranates. There is also a palm tree which is a symbol of victory over death.

Inside the shrine-like building, Mary sits on a golden throne which glitters, but looks unrealistic and uncomfortable. However, the visual dynamics and structure of the picture require something like this in that position. She wears a blue outer robe – the colour of the sky, of infinity and immateriality. The pigment is lapis lazuli, the most expensive pigment available – only the best is good enough for the Virgin Mary. This robe is lined with green – the colour of new growth and birth, of spring, of hope. Her red robe is the colour of blood and earth – a symbol of love and passion. All the garments are bordered with gold – a symbol of divine light. She wears a fine transparent veil which has been drawn back from her face. A member of the congregation of San Domenico in fifteenth-century Cortona would have known that she is portrayed as a contemporary member of the Florentine aristocracy.

There are one or two puzzling details which I confess I find difficult to fathom. Tucked into the Angel Gabriel's golden locks is a curious red chilli like object. Could it be a symbol of this fiery nature of his divine mission? The dove of the Holy Ghost sports a chic red beak and feet, and I have an uneasy feeling that they are somewhat too stylish to be authentically early fifteenth century. Do they and the rim on the halo of dove owe more to a recent bored restorer hoping to liven things up a bit? Similarly could it be that the red chilli in the Archangel Gabriel's hair might have been added at the same time?

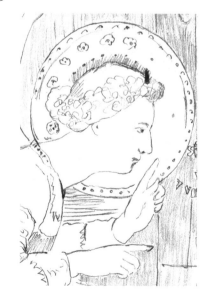

In the stonework of the spandrel a figure, carved in relief, looks down. Could it be God the Father giving a blessing? If it is, why is he using his left hand? The other possibility is that it is a portrayal of the prophet Isaiah. He holds in his right hand a scroll on which one would have expected to see written 'A virgin shall conceive' and so his left-hand gesture would have no particular significance. Why is nothing written on the scroll? Perhaps there never were any words or perhaps, like the Mona Lisa's eyebrows, they were removed a long time ago by a restorer using an unwise solvent. Either way it makes no difference to the fundamental meaning and visual beauty of *The Cortona Altarpiece.*

The building in which Mary sits is flooded with celestial light. Beyond the fertile garden is a strip of brown wasteland. Easily overlooked is the distant scene of the expulsion of Adam and Eve from Paradise. The Archangel Michael stands at the gate of the Garden of Eden whose golden interior glows like that of Mary's shrine. He holds a sword

in his right hand and his left rests on Adam's shoulder in a gesture which, to my eyes, is one of manly understanding and regret, equally reflected in the sadness of his facial expression. Adam and Eve are barefoot and wear garments which seem to be made of animal skins. Eve clasps her hands together either in prayer or despair, or perhaps both, her face pale, her eyes dark and heavy as they would be from weeping. Adam puts his hands to his face as one does when faced with the realisation of profound tragedy, or error that cannot be undone. Over the crook of his right arm he carries a hoe or scythe, for as told in Genesis Chapter 3, verse 19: 'In the sweat of thy face shalt thou eat bread, till thou return unto the ground; for out of it wast thou taken: for dust thou art, and unto dust shalt thou return'. For me it is a breathtakingly wonderful piece of human observation by someone with profound understanding of the human condition.

Fra Angelico was a pioneer of scientific perspective – some scholars arguing that he was ahead, even by a whisker, of Brunelleschi. For them mathematics was not a dry and abstract matter but a means to an end. Properly applied, he believed it could bring a new sense of realism to painting, and beauty and proportion to architecture. Mathematics and

geometry could also have symbolic meaning. The circle was the symbol of eternity, representing both the perfection of God and the everlasting God. The square stood for earthly matters and earthly existence. The equilateral triangle symbolised in its three points and symmetry the Three in One: Father, Son and Holy Ghost.

Mathematics make an important contribution to *The Cortona Altarpiece*. The shrine in which Mary sits is contained within a precisely calculated square. Outside the shrine (and the square) are the garden and the scene of the expulsion from the Garden of Eden, both portrayed in subdued light. It is very simple, but to my belief deeply significant. If you draw the diagonals of the square, they meet precisely at the fingertip of the Archangel Gabriel's right hand.

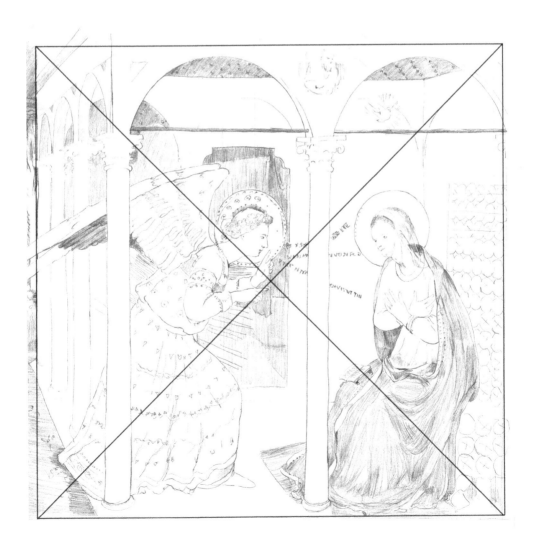

Having discovered this symbolic geometry – and it is so precise it cannot be accidental or haphazard – I looked for a circle. It is easily drawn in, and the centre is also the fingertip. In other words, within the Earthly (the square) can be found the Divine (the circle). At the centre of both is the conception of Jesus Christ.

Have I missed something, e.g. a triangle? Given half a chance I will start discovering non-existent squares, circles and triangles everywhere and, as a result, fall into the trap of over-intellectualising, and searching for 'difficulties'. Once so engaged I shall no doubt find them in quantity. The proper purpose of scholarship is not to go searching for problems which turn out to be unsolvable (because non-existent), but to seek answers to questions which genuinely emerge through a thorough and objective examination of the evidence. Fra Angelico, although learned,

was not complex. What he needed to put in he put in, and what he did not need he left out. I hear him saying to me:

> Which square inch are you referring to, Robert? If you over-fuss about the symbols and hidden meanings, you will blind yourself to the beauties that I have so carefully tried to craft. Why don't you just sit back and enhance your life by looking at, taking pleasure in and receiving spiritual fulfilment from what I have so joyously and gloriously painted? It is through beauty, not symbols or searching for false 'problems' that you will gain insight into divine truth. It is in harmony and proportion, such as the symmetry of the square and the circle, that the purest beauty and the surest faith is to be found.

The Cortona Altarpiece is such a cornucopia of divinely inspired visual delight and of intellectual and spiritual stimulation, with so much unexpected detail and hidden symbolism, that we may be surprised how time has slipped away. I think Fra Angelico would hope that our experience might have brought us nearer to his God, but I also think he is sufficiently a man of the world to consider that if he has caused us to think deeper about who we are as human beings and about our relationship with others, with nature, with the universe, even speculate what happens after death, then he will have succeeded in some of his aims.

Having fed the mind and refreshed the eye it is now time to feed the body and slake the thirst. Let us hope we can eat and drink in the open air, the earth beneath our feet and the canopy of heaven with its stars and planets above our head, the sound of crickets to please the ear, the scent of sweet basil on the nose, and the balmy warmth of Tuscan evening air to caress the body. We should sit in silence to let our senses be fulfilled and ponder on what Fra Angelico has shown us.

Do I believe in the Annunciation and the Virgin Birth as a historical event and a scientific possibility? No, I do not. Can I accept Genesis Chapter 1 as an accurate and scientific description and explanation? No, I cannot. Does that present me with a problem? It once did, but no longer. Once the penny dropped that there are two sorts of truth,

scientific truth and poetic truth, and that it is possible to hold these two truths concurrently and separately in the mind at the same time without any conflict between them, simply as complementary alternatives, I found a sort of personal release and fulfilment. Is the idea that God created our tiny planetary system in seven days any more improbable than the idea that the whole of the universe came about as a result of something called the Big Bang? In time the latter is as likely to become as discredited as every other theory about the origins of the universe. Yet it is an integral part of human nature to be constantly searching for a currently convincing definition or explanation of the ultimate truth. Until somebody comes up with a definition that can stand for all time, as opposed to satisfying the needs of the moment, Genesis Chapter 1 and Luke Chapter 2 will probably hold their place, for me, as the best poetic truths I can possibly hope for.

How necessary is faith? Fra Angelico had faith. It is there with ringing clarity and certainty in each square inch of *The Cortona Altarpiece*. The faith that he possessed was necessary for survival in the world in which he lived. His Christian faith offered hope, solutions, and answers to many of the problems of his era: injustice, famine, poverty, warfare, the depredations caused by nature and human stupidity, and the inevitability of death. Above all, his Christian faith offered the possibility of triumphing over death, through the promise of the Resurrection and the life to come. His Christian faith also gave him a moral compass, a set of guidelines for the living of a good and useful human life, a set of values to aspire to if not always achieve.

Without faith the human race would probably not survive. The faith that supported Fra Angelico is not widespread today and is often sneered at. However, it is not that we, collectively, have lost faith. We have simply replaced Fra Angelico's faith with another. We still face the same human problems, and we still have to conquer death. Modern faith believes that we will overcome all these problems by harnessing the power of technology and money. In Fra Angelico's day the clergy and itinerant priests constantly demanded more prayer and worship of the Deity as the answer to the problems they faced. Our present-day secular Western 'priesthood' and its itinerant 'preachers' constantly

demand the provision of more financial resources and better use of technology as the answer to the same problems. Yet is this new faith any more successful than the old faith? How useful or comforting is this new faith to those inhabitants of the planet who have no access to financial resources or technology?

Were I ever to be marooned on a desert island I will, of course, have no usable technology or money, and no resources other than those provided by the earth, the air and the sea. To survive I will still need faith. I will certainly need hope, and without charity (i.e. loving kindness) life might be bleak. I will need to believe, as well as just hope, that I have a future and that in the end I will be physically or spiritually rescued. Without a fellow human or a dog, Charity (loving kindness) will be hard to come by, although wild animals and birds are capable of forming remarkable bonds with humans. In such circumstances Fra Angelico's faith will probably be a great deal more beneficial than faith in money and technology.

Painterly Reflections by Gino – Fra Angelico

Perfection and attention to detail were the first characteristics I noticed in Fra Angelico's work. He gives much thought to the way perspective, line and rhythm coordinate with colour to achieve a coherent composition. He is particularly alert to volume and perspective and how they influence our perception of reality. Most importantly, Fra Angelico has a sensibility that is humble. Brashness and ego have no place and offer no distractions. He embraces purity and beauty in nature to realise a religious sensibility where spiritual thought unites with physical reality.

Fra Angelico is quietly innovative in his painting processes and quietly radical in his use of a variety of different materials and different styles. He uses geometry to create balance and harmony and employs colour to define the figures in the story and helps us read the iconography. He uses the predella storyline to help us understand the messages in the main panel.

Glazing is a key technique creating a variety of translucent, opaque and layered surfaces. With these he creates nuanced paint hues and very subtle colour modeling to render depth and volume.

A prime example of his experimental approach is his use of gold leaf to give lustre and prominence to religious figures. He demonstrates a variety of skills including water gilding, punching and granulation, incision, burnishing, and sgrafitto, and also applies glazes to the gold leaf. These techniques are not just for visual effect or to create texture but also to acknowledge the significance of each figure in the painting and to create a feeling of transcendence.

My introduction to egg tempera techniques was during a course on Conservation at Kelvingrove Museum as part of my degree at Glasgow School of Art. Using the medium required discipline and a good understanding of the properties of the medium and the techniques to be applied in its making. Of primary importance was to understand the fragility of the medium during its application. I soon recognised the difficulties that arise when egg tempera is used incorrectly. Patience and discipline are key virtues when using egg tempera. Painting onto a

surface coated in six layers of gesso with each layer sanded to a glassy surface means the preparation time was lengthy. However, the benefits outweigh the slow preparation time. I also soon realised that having a very good understanding of how colour and light behave, particularly when applied in thin washes over each other, is absolutely essential.

Canaletto's
The Arrival of the
French Ambassador in
Venice (1726 - 1727)
is in The Hermitage,
St Petersburg

After Caneletto
ink wash on
watercolour paper

Canaletto
The Arrival of the French Ambassador in Venice

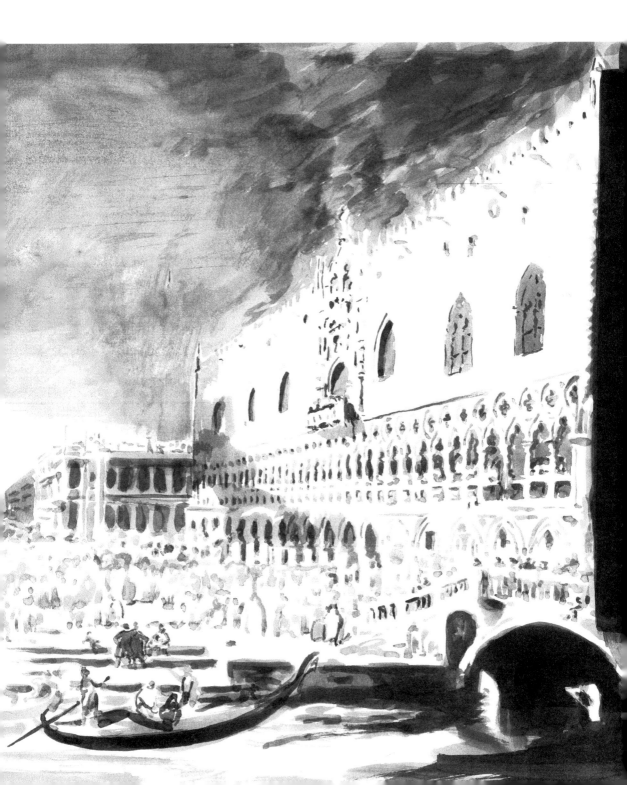

Canaletto

The Arrival of the French Ambassador in Venice

I hope you will be surprised by the choice of a Canaletto as the third picture we should look at together. Equally, I hope that you will be pleased at the prospect of visits to two of the most romantic and visually beautiful cities in the world. First, we must go to St Petersburg in Russia, to the Hermitage Museum where Canaletto's spectacular picture is now displayed, and then to Venice itself to explore the view that he painted.

Travel to Venice is straightforward, whereas St Petersburg is anything but, and was tricky even seven years ago. Carolyn and I spent a week there in 2017 when diplomatic relations between Britain and Russia were relatively benign. Such a visit will be more difficult now, but not impossible, and it is very definitely worth every exertion to make it happen. Let us agree to make our own arrangements and rendezvous at the State Hermitage Museum. Please make sure you come equipped with a pair of binoculars and a magnifying glass. I would like to suggest that we ask Dr Irina Artemieva to join us to contribute to our discussion. She is the Curator of Venetian paintings at the Hermitage, and before our visit in 2017 I had been in touch with her. It would be a pleasure to see her again.

The queues for entry to the Hermitage are legendary and slow moving. Fortunately, there is an easy way round the jam. A membership card for the UK Friends of the Hermitage allows entry through the Director's entrance at the back. The Museum is conveniently open until 9 pm on two days a week. By that time the relentless guided tours have departed, and it is possible, in peace and quiet, to get a close look at the great masterpieces, including our Canaletto.

I first saw *The Arrival of the French Ambassador in Venice* in 2010 at a major exhibition at the National Gallery in London. For me, it was truly love at first sight. As an ignorant youth I had always dismissed all of Canaletto as nothing better than a glorified version of painting by numbers (although I still think that his later work can deserve such a description).

Doubts about this confident and dismissive opinion began to creep in on learning that the best of all British painters, J.M.W. Turner, was an admirer. The doubts gained strength on discovering that Whistler thought he was one of the all-time-great masters. It was only when seeing with my own eyes and for the first time a range of his early works, with their special cool, silvery light and atmosphere, moody large skies, chasing shadows, thrilling open brushwork, and authentic anecdotal people, that I realised just how good a painter Canaletto could be. That was in Dresden, in the early 1990s, before they were subjected to current notions about cleaning and restoration. *The Arrival of the French Ambassador* is such an early work, painted when the artist was in his mid-30s, at the very start of his career.

As we shall discover, the picture is a cornucopia of surprises. That, for me at least, is a crucial part of the picture's delight. My favourite bedtime reading is a 'whodunnit' from the golden age of classic crime mysteries, for I enjoy the sleuthing and trying to unravel the clues. In this case the detective work will seek to answer such questions as: Is the picture really by Canaletto? Why is the picture in Saint Petersburg? Who is the Ambassador? Where is the Ambassador? Where in Venice can I find this exact view? What was the ceremonial occasion? When did it take place? Was Canaletto present, or is it all an elaborate theatrical fiction?

It is such a large picture that anyone might be forgiven for wondering if it is indeed by Canaletto. Normally his pictures are of a modest size and subject matter, appropriate for a nobleman's private study or the drawing room of an English country house. This, roughly seven feet by nine feet, is better suited to a prince's palace. *The Arrival of the French Ambassador* is to be found at the very heart of this lavish storehouse of art, in the enormous and sumptuous 'Large Italian Skylight Hall', which is densely hung from dado rail to ceiling with Italian masterpieces of the seventeenth and eighteenth centuries. You will need the binoculars

to look at the architectural detail as well as paintings which are hung 20 or more feet off the ground. These huge, elaborately framed pictures, mostly with obscure mythological and biblical subject matter and over-life-sized figures sit comfortably together in this grandest of galleries, and have as their companions elaborately encrusted gold furniture, marble statuary, muscular Russian torchères and malachite vases.

The only thing he has in common with the others is that all the painters were Italian, and that his picture is also large. We might well observe how all the guided tours pass rapidly through this magnificent hall, stopping only at the Canaletto which is conveniently hung at head height. I suspect the reason is that 'Canaletto' will be the only familiar name among all the artists on show, and because it is immediately recognisable as a view of Venice.

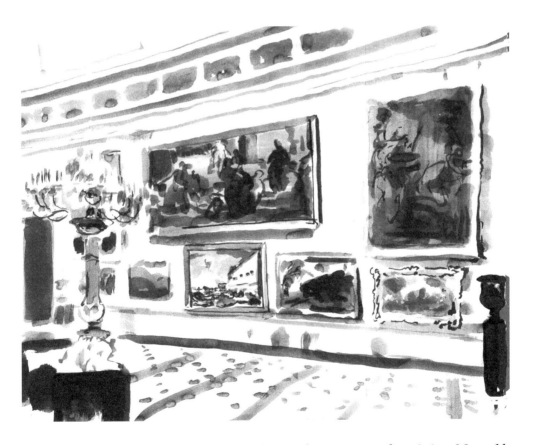

Like sport, looking is as much a physical as a mental activity. No self-respecting athlete would dream of going out onto the running track or football field, tennis court or golf course, without some limbering up to

warm the muscles, stretch the tendons and concentrate the mind, and without making sure there are moments of relaxation and refreshment. Before getting to grips with *The Arrival of the French Ambassador* we ought to do a few limbering up exercises in order to get our eye in. One of the favourite games at the Tate Gallery, much enjoyed by families because it appealed to all ages and could be shared, was 'Spot the Detail', e.g. 'Can you find the dog in this picture?' If you think that finding the dog in the Canaletto is a bit beneath you, let me change the question to 'How many dogs can you find?', or 'How many how many monks are in the crowd?'

I guarantee such questions will lead to disagreement amongst us, as well as produce some surprises. Having limbered up with that, I might then challenge you to find the one-legged beggar or ask: 'How many people are wearing carnival masks?' If nothing else it will cause you have a good search of the figures on the Molo, on the gondolas and thronging the balconies. I shall then ask: 'Whilst searching, did you spot the French Ambassador?'

He is not prominent or obvious. In fact, he has just alighted from his barge (it is possible to work out which one because it carries a blue escutcheon bearing the fleur-de-lys of France below a coronet, nestling against a red escutcheon with the arms of Navarre). Having reached dry land he is escorted by a formal procession which snakes from the Molo to the Doge's Palace. Canaletto has placed him at the (horizontal) centre of the picture, exactly halfway below where the diagonals meet and

the bottom of the picture frame. You need to look to the right of and below the two granite columns, into the sunlit space of the pavement, above the broad steps which lead up from the water's edge, to where the crowd of onlookers has conveniently parted to allow the Ambassador to turn to look at us.

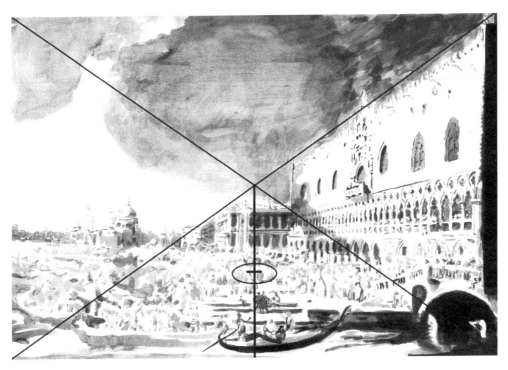

His procession is headed by regimented state officials and youths dressed in elaborate blue or red costumes with tricorn hats and followed by a less orderly straggle of senators in long red robes and full-bottomed wigs.

Today, no politician or diplomat arrives in state in Venice. State visits to capital cities are made, often fleetingly, by the heads of state themselves. Ambassadors no longer have the autonomy they once had. In the eighteenth century, however, when monarchs did not, and could not, travel as they now do, ambassadors were treated as royalty. Even now, the costumes and ceremonial tend to remain much the same as in Canaletto's day, as does the behaviour of the high and mighty. What has changed most are the carriages or vehicles in which they travel.

To tell the truth, I find most of the dignitaries that are assembled for official occasions to be a dull and pompous lot. Although they are splendid en masse in their finery, individually they are not exciting. It is the orchestration of events, the stage management, that I find most fascinating. The best moments for the armchair scrutineer are when something goes slightly awry or someone is unfortunate enough to be caught surreptitiously yawning, or a child or animal misbehaves.

I think that Canaletto was well aware that he had to do something to relieve the static tedium of the state occasion. The solemn snail-like pace of the Reception that takes place in the right-hand two-thirds of the painting and occurs on dry land. By contrast, everything that occurs in the left-hand third occurs on water and is in motion. He takes pleasure in the jostling movements of the gondolas as they bob up and down unpredictably like corks on choppy water.

Just as Shakespeare introduced the banter of lower class 'mechanicals' to relieve the seriousness of the dramas played out by the upper classes, Canaletto is astute enough to enliven his picture with beautifully observed, convincing, anecdotal everyday detail. Jostling, competitive gondoliers exchange shouts and oaths, and dogs bark at each other, oblivious of the solemnity of the occasion, or sit in motionless dignity on an owner's gondola. Among the crowd on the Molo are finely dressed ladies, monks and prelates, street vendors, exotic visitors from North Africa and Asia Minor with their characteristic dress and colouring, and a one-legged beggar on a crutch with an urchin. Many are wearing carnival masks. Every accessible perch, balcony or vertigo-inducing, suicidal ledge is thronged with people who have gathered like insects on windowsills.

Put at its simplest, Canaletto gives me the sense of actually being there on 4 November 1726, eager to witness the arrival of the French Ambassador, Jacques-Vincent Languet, Comte de Gergy. He is the portly, late middle-aged figure clad in black court dress with red and gold trimmings, sporting elegant stockinged legs, holding an elaborate white-feathered hat in his right hand. He stands with his host who is on his immediate left, dressed in a long red gown which sweeps the ground. They have adopted the pose that all visiting ministers and heads of state assume when greeting each other. Well-rehearsed, they shake hands and look towards the onlookers, smiling. That is why they look directly at us, and we look back at them as if we were the press corps.

Both will be keenly aware that Venetian power has been in steady decline since the end of the fifteenth century when a sea route to the Orient was discovered round the southern tip of Africa. Both also know that Venice currently has difficulties with its territories in the Balkans and harassment from the Ottoman Empire. In short, La Serenissima badly needs friends. The cunning Ambassador will no doubt seek to secure some advantages for his teenage King, Louis XV, and many more for himself.

For generations the de Gergy family have loyally served as churchmen or court officials. None of them have achieved an exalted rank, and to be appointed Ambassador to Venice is probably as good as it gets. By the age of 30 the young Jacques-Vincent Languet was an Ordinary Gentleman of the King's Chamber. He then received appointments as envoy to the Duke of Wurttemberg, the Duke of Mantua and the Grand Duke of Tuscany. His father was Attorney General of the Parliament of Burgundy, and his mother was the daughter of the second President of the Parliament of Burgundy. At the age of 48 he married the daughter of the Treasurer General of the Galères de France (a society for those who had served on French warships). They had a daughter who was a babe in arms when they arrived in Venice in 1723, the Comte de Gergy then being 56 years old with a decade left to live.

Guests on the BBC programme *Desert Island Discs* are always asked to choose a book that they would like to take, other than the Bible or the complete works of Shakespeare which are already on the island. My choice would be for the complete works of T.S. Eliot. I know some of the poems by heart, and I cannot look at the Ambassador without hearing these words from 'The Love Song of J. Alfred Prufrock':

> *Am an attendant lord, one that will do*
> *To swell a progress, start a scene or two,*
> *Advise the prince; no doubt, an easy tool,*
> *Deferential, glad to be of use,*
> *Politic, cautious, and meticulous;*
> *Full of high sentence, but a bit obtuse;*
> *At times, indeed, almost ridiculous –*
> *Almost, at times, the Fool.*

The minute level of detail we have been looking at means that we shall have had to stand close to the painting, probably using our magnifying glasses. I suggest that we now stand back and look at the painting as a whole, for it is only by losing the detail that it is possible fully to appreciate the extent of the young Canaletto's truly magical way with paint. Here it enables him to spirit up the ethereal distant facade of the great votive Church of the Salute, enveloping it in an illusion of that soft winter light which drains but does not extinguish colour, rendering everything as if seen through a gauze curtain. The church seems to float as if a galleon riding at anchor, captured at a momentary and almost imperceptible angle to the horizontal. Then, if we turn our eyes further to the left, there can be seen through the same gauzy haze, the stretch of water that separates the main island from the smaller snaking island of the Giudecca with, on its waterfront, a glimpse of Palladio's facade of Il Redentore.

The Salute was barely a century old when Canaletto painted his picture, a new addition to the skyline, guarding the entrance to the Grand Canal, built (like Il Redentore) as a thanksgiving for salvation from a terrible outbreak of plague. In a city of effluent-rich 'stinking ditches', and in its early days built mostly of wood, disease and fire were constant hazards which regularly took their revenge.

Fire was mitigated by designing special chimneys with a contraption looking like a large bucket at the top that caught the sparks and hot pieces

of burning wood which drifted up and out of the chimney (they can be seen on the white buildings in the middle distance. Something similar was fixed to the trains of the early American Midwest railroads), and by moving the glass industry, which needed red-hot furnaces, out to the small island of Murano in the lagoons. Plague was less easily dealt with, and even today Venetian plumbing can cause anxiety.

Common sense indicates that a picture this large did not come about by chance, nor was it a speculative venture produced in the hopes that somebody might come along and buy it. There has to be a patron; but who? The other conundrum – and this burrows deep into the minutiae of scholarship and connoisseurship – is that there appears to be a companion picture of exactly the same dimensions depicting the Bucintoro, the Doge's state barge, returning to the Molo, on Ascension Day. This was the moment of Venice's grandest annual state occasion, when the Doge was rowed from the Doge's Palace, with his senators, out to the Lido. There he ceremonially dropped a gold ring into the waters of the lagoon to symbolise the marriage of the Venetian Republic to the sea, for it was on the success of that marriage that the future prosperity of the Republic depended.

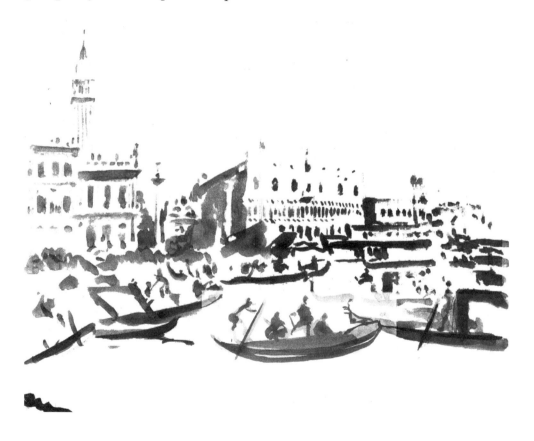

Grand pictures like this were often commissioned as pairs. The most likely patron for both would seem to be the French Ambassador himself. Although there is no record of his having commissioned any paintings from Canaletto, he is documented as having commissioned music from

Vivaldi. The Comte de Gergy was once present at the ceremony of the Doge marrying the sea – indeed, the companion picture includes his barge with its blue escutcheon displaying the fleur-de-lys of France.

The Ambassador did not stay in Venice for very long, about four years. It is said that he returned home because of ill-health. Perhaps the smelly, damp atmosphere of Venice did not suit him? Did he commission the pictures before he left? Were they completed during his stay there? Did he return to France with them or were they sent on later? Did he commission them after he got home, wanting to have a souvenir of his sojourn? Did he not receive them? There are other tantalising questions of connoisseurship such as: Is the style and brushwork in which it was painted that of the 1720s, or that of the 1730s? There is a difference. Since the Ambassador died in the early 1730s, is it possible that he commissioned them, never received them before he died, perhaps because they were not finished, so he never paid for them, with the consequence that Canaletto later disposed of them elsewhere? Much as I like this sort of detective work, I could not find any convincing answers.

It was the delightful and generously helpful Dr Irina Artemieva who provided the answers. First, and most courteously, she showed me that I had made the mistake that I so often warn my students against: believing what is written on the label or in the books rather than what they can see with their own eyes. How often have I said: 'if you cannot see it, do not believe it!' Yet here I was making exactly that error. I had rushed to the conclusion that the 'Arrival' meant the first presence of the French Ambassador in Venice – if not literally stepping onto Venetian soil for the first time (he would have travelled along the River Brenta to Fusina, and then by boat across the lagoons into Venice herself), then arriving at the Doge's Palace in order to present his credentials. Can I see any of this, or anything to justify such a conclusion? No, I cannot. His 'Arrival' is unquestionably at the Doge's Palace, that I can see. However, it turns out he had actually been in Venice for several years before taking part in this elaborate ceremony.

Apparently, there had been no diplomatic relations between France and Venice for well over a decade and the Comte de Gergy was given

the task of resuming them. The negotiations took the best part of three years and the ceremony which Canaletto depicts is a celebration of the successful conclusion when the treaty (or whatever the document was) was formally signed and sealed by both sides. It was a grand affair that took two days to complete. On the previous day the Ambassador had travelled to Chioggia, a town on the very southern edge of the lagoons, about 20 miles south of the main island of Venice. There he was met by the 'Cavaliere della Stola d'Oro', Niccolò Tron, accompanied by 60 deputy senators. All of them then progressed in gondolas to the French Embassy, and the next day the elaborate procession with all its meticulous protocol took place, more or less as Canaletto shows it, in front of the Ducal Palace. Nonetheless there was a sting in the tail. De Gergy was required to foot the bill personally and entirely for this elaborate and prolonged ceremonial event.

Who wouldn't want such a picture to record such a momentous (and expensive) occasion, and the successful completion of a diplomatic mission? So accurate, correct, and lifelike are all the details that the picture must have given de Gergy a boost every time he looked at it. Perhaps the diplomats and politicians of today gain their thrill by re-playing the newsreels or revisiting the televised broadcasts?

As I understand it, no single detail in this picture is inaccurate or capriciously invented. Even the white masks worn by some bystanders are precise since these particular masks were worn not just at Carnival time (as they are now). Strictly regulated by the government, and only permitted to be worn by Venetian citizens, it was obligatory to wear them at certain political decision-making events when all citizens were required to act anonymously as peers. It is Tron, in his red robes, who stands next to the Ambassador, and near the lady in blue with a young girl. As these both wear masks they cannot be either the Ambassador's wife, or his infant daughter. My guess is that they are Tron's family.

Irina explained that the paintings were commissioned by the Comte de Gergy, who paid for them and received them. When he died his executors sold them to a French dealer who sold them to Catherine the Great during her reign, between 1763 and 1796. I suspect they were early acquisitions by her and something of a coup for they are pictures that tick all her ambitious political boxes, but that is my fanciful guesswork.

It was the Empress Catherine who, during the century after its foundation, turned St Petersburg into Russia's cultural capital and most European city. She was a German princess born into minor German aristocracy. Formidable and ruthlessly ambitious, she had been betrothed aged 14 to the neurotic and drunkard grandson of Peter the Great. By disposing of him and all opposition she became a much loved and admired Empress of All the Russias.

St Petersburg had been founded by Peter the Great at the turn of the seventeenth and eighteenth centuries on a flat and unprepossessing piece of land in a remote corner of Russia. The site chosen had, by virtue of its mild climate, the possibility of year-round ice-free access to the Baltic. The principal feature that Venice and St Petersburg have in common is water and canals, and, for good reasons, St Petersburg soon acquired the nickname 'Venice of the North'. Peter the Great's intention was that his new city was to be Russia's 'Window onto Europe'. It was one of the many attempts by the Russians to seek equality, possibly friendship, with the great powers of Western Europe, and to open up opportunities for trade. Catherine's intention was to make the city a showcase of Russia's European credentials by means of spectacular examples of architecture and art based on Western precedents. Many of her grandest and most spectacular buildings line the tributaries and canals of the Neva River. Today, St Petersburg shimmers as though newly built – after the collapse of the Soviet Union enormous sums of money and energy were devoted to renovating the deteriorated facades and cultural landmarks in order to re-establish Russia's Western European status and entitlements.

The State Hermitage Museum was founded in 1764 by Catherine as a court museum. It adjoined her Winter Palace and served as a private gallery for the art collection of the Empress. She had started to collect

works of art as soon as she became Empress, not purely for private enjoyment, but as a tool to put herself and her country at the heart of European politics, and to show that she was the equal to, if not greater than, any of other European monarchs. If, today, displays of troops and weaponry are used as the outward show of national pride and prowess, in the eighteenth century art and architecture were used for the same purpose. Catherine employed agents to seek out and purchase pre-existing European private collections as and when they came onto the market. As a result, she amassed some 4,000 paintings, 38,000 books, 10,000 drawings, and 10,000 gemstones. She took great pride in her collection and actively participated in the competitive collecting then prevalent in European court culture and politics. She identified herself with the Roman deity Minerva, whose principal qualities were military prowess, wisdom and patronage of the arts.

In the reign of Tsar Nicholas I, and after a fire at the adjoining Winter Palace in 1837, the Hermitage was reconstructed. It was opened to the public in 1852. Following the October Revolution of 1917, the imperial collections became public property, and the museum was expanded in the 1920s with works of art requisitioned from private collections. The museum is now the largest art museum in the world by gallery space, housed within five interconnected buildings. The Winter Palace and the Small, Old and New Hermitages together contain over three million items. Although a long way from 'home', *The Arrival of the French Ambassador* has found, in my view, a very suitable resting place. I think that Canaletto would be content for his picture to occupy a prominent place in the most sumptuous gallery of such a spectacular museum.

We have had a lot to take on board by way of history and culture, some of it perhaps new or unfamiliar, so this may be the moment to think about making our way to Venice to see if we can find the view that Canaletto painted. However, before we leave St Petersburg, I shall insist that we

make several expeditions to catch a taste of tsarist St Petersburg and communist Leningrad, in order to understand more about the Russian psyche. Ideally, I would like to introduce you to some of the experiences that Carolyn and I found most valuable in 2017. On that occasion we enjoyed truly memorable performances of Stravinsky's *Firebird Suite* and *Les Noces* at the delightfully intimate nineteenth-century Mariinsky Theatre, and Tchaikovsky's *Sleeping Beauty* at the grander, more formal Mikhailovsky Theatre. We also attended a Sunday morning service at Kazan Cathedral, and experienced the mysterious rituals of the Russian Orthodox Church with its unfamiliar music and chants. We made expeditions by car with a knowledgeable Russian guide who had been brought up in Leningrad as it then was, to the palaces of Tsarko Seloe and Pavlosk. We also spent some time with her at the Siege of Leningrad Memorial trying to grasp the horrors of that terrible event. For nearly 900 days the city was blockaded, with no way in and no way out. It resulted in the worst famine ever in a developed nation. The inhabitants of the city ate rats and wallpaper in order to stay alive. Over a million civilians died of starvation and hypothermia, but they never surrendered. By the end of our week, Carolyn and I were beginning to have inklings of the overwhelming scale of the Russian imagination, their capacity for suffering, their fortitude, their patriotism, and the unfathomability of the Russian mind, and why, thanks in part to Napoleon and Hitler, they still harbour deep suspicions about the trustworthiness and motivations of Western-bloc politicians.

Venice is roughly 1,500 miles by road from St Petersburg, more or less the same distance as is London. There is no direct flight to Venice. It would mean going via Istanbul or returning to Helsinki. It is possible to go by bus which would take roughly four days. However, I would like to suggest that we go to Venice together by train, for even a modern train journey retains a certain air of romance and adventure. Also, it is only by travelling over land that it is possible to begin to grasp the distances, the varied landscapes and cityscapes, and the multifaceted cultural nuances that make Europe such a rich continent visually and emotionally. To begin to understand the Russian spirit it is imperative to experience the vastness, harshness, tedium and loneliness of its climate and landmass, together with the days and distances required to cross it.

There is a fast train between Petersburg and Moscow which travels the near 500 miles in about four hours. Once in Moscow we would be able to visit the Pushkin State Museum of Fine Arts to see the companion piece to *The Arrival of the French Ambassador,* which is *The Doge's State Barge Returning to the Molo, on Ascension Day.* I have never seen this picture in the flesh but from the photographs I have an uneasy feeling it might be a later painted replica rather than by Canaletto himself. I am probably wrong, but I would like to put my mind at rest. Close examination of available photographs indicates something very formulaic about the painting of the waves, and the beautiful atmospheric light seems to be missing. Perhaps it has been so viciously over cleaned so that all the top glazes which would have given subtlety and atmosphere have been wiped off. The reason that the two paintings are no longer hung together is that after the Revolution of 1917, when the imperial Romanov treasures were being redistributed, it was decided to allocate one of the pair to Leningrad and one to Moscow.

From Moscow we would need to go by train to Warsaw, a train journey that takes nearly 20 hours for a distance of approximately 800 miles. From Warsaw to Vienna there is a fast intercity train which takes 7 1/2 hours to cover 450 miles. From Vienna there is an intercity train which takes seven and a half hours, by way of Trieste, to cover another 400-odd miles. Unless there are sleeper trains the journey will take the best part of a week. Why not? It would be old-fashioned leisurely travelling with much to see and, with an agreeable companion, plenty of time for reading and discussion. I just hope that all the trains will have old-fashioned dining cars and edible food!

If we take the train to Venice, it will inevitably mean that we will arrive at her unattractive back door at the wrong end of the Grand Canal. Venice's front door is the view that Canaletto painted in the picture in St Petersburg. Until 1846 the only way to reach the city of Venice from the mainland was by a boat across the lagoons, landing at the Molo in front of the Doge's Palace. It was one of the features that made Venice so appealing and romantic. The coming of the railways put an end to that. A railway bridge was constructed to join Venice to the mainland, and in the 1930s Mussolini added a road causeway. Most people reach Venice from the mainland today by the back door at the seedy end of the Grand Canal, including those who come by plane and take the airport bus.

Perhaps in the end we should take a plane from Helsinki, or at least make sure we do the final leg of the journey from Vienna or Trieste by plane for one simple good reason. It is possible to take an inexpensive communal water bus from Marco Polo Airport. This will meander slowly across the lagoons and eventually disembark its passengers at the Molo and the Doge's Palace. As it crosses the lagoons the water bus will make various stops – Murano where glass is made, Burano with its brightly coloured houses and lace makers, the Lido where Thomas Mann set his tragic novel Death in Venice – and pass by the tiny island of San Michele where the Venetians bury their dead. Each stop might give cause to ponder the different moods of Venice and the way the interplay of light and water on the eye can play to the emotions just as music plays to the ear. Both can induce profound joy and happiness, or deep personal melancholy and sadness. If we catch a flight arriving in the early evening at a season when the days are long, the itinerary across the lagoons will recapture something of the atmosphere of arriving in eighteenth-century Venice. It is pure magic, and the only decent way to arrive.

Whichever way we travel there will be plenty of time to discuss Canaletto and exchange opinions about what made him tick. He was born at the very end of the seventeenth century, somewhere between 1690 and 1700, and died at the age of about 70 – a good innings in those days.

His father, Bernardo Canal, was a theatrical scene painter who taught his son all the tricks of that trade. From an early age he acted as his father's assistant – in his early 20s he went with his father to Rome to execute scenery for two operas by Alessandro Scarlatti. Soon after this visit he started to draw and paint architectural views. He called himself Canaletto ('The little Canal') to distinguish his work from his father's. The young man used all the tricks that his father taught him to bring a refreshingly new refinement and glamour to what had always been a humdrum activity – view painting (*vedute*, the Italian expression for topographical views, especially precisely rendered views of a known location).

There is every reason to suppose that Canaletto's childhood was happy and fulfilling – the sort of childhood I might have wanted for myself. Venice was a place full of excitement, vitality and colour, music and foreign languages. There was a daily throng of tourists and visitors, merchants from north, south, east and west, ships arriving and departing – the panoply of the crowds and activities in our picture. For a boy with Canaletto's talent and imagination it would have been a visual feast and inspiration. Every day he would have witnessed or participated in the world of the theatre with its actors, singers, musicians, playwrights, stagehands, directors and producers, assisting his father in the creation of sets, scenery and lighting. Being a child, he would have been a willing observer at one remove, aware of but uninvolved in the dramas of adult politics, bickering and bitterness which seems to be an inescapable feature of the world of theatre. Later he would discover that the art world is every bit as tough and unforgiving. The Italian art establishment never liked Canaletto and only reluctantly was he elected a member of the Venetian Academy when he was well into his 60s. He never married and had no children. He died sadly alone, if not in genuine penury, then certainly in very straitened circumstances.

Canaletto was a canny operator. Early on he spotted an opportunity to make serious money. The theatrical scene painter's art is one of illusion like no other. Spaces can be created out of nothing, light can be made to do unnatural things, buildings to appear and disappear, the audience be made to float in space, time and imagination. The rich British 'Grand Tourists' who flocked to Venice wanted magical, easy-on-the-eye topographical paintings, small in scale, which they could take home

as a souvenir of their travels abroad. They had deep pockets for the right thing. There were many artists willing to play to their needs, but Canaletto's genuine and original artistic talent plus his commercial shrewdness ensured his status as most-favoured painter of *vedute*. Many of the Grand Tourists wanted a picture just like the one that their friend had recently bought, and Canaletto was not ashamed to repeat himself.

I always think that there is something rather unlikely about the British nobility and gentry descending on Italy in hoards to satisfy a voracious hunger for aesthetic experience, for which they would risk life and limb, and occasionally death. No one in their right mind now would risk death in order to see a famous building, a sculpture or a painting. Nonetheless, alongside the desire to get away from home, and a youthful exuberance and thirst for adventure, aesthetic experience was one of the compelling reasons for going on the Grand Tour. The principal places for fulfilling these impulses were Florence and Naples. On leaving the shores of England, tourists usually travelled south through France, then over the Alps into Italy, with stops in Turin and Milan. From there they went to Naples by way of Florence and Rome. Florence appealed to the intellectuals and those wishing to experience Renaissance art, notably Raphael and Michelangelo. Rome was tempting because of its classical antiquities, but it had grave disadvantages, principally that the Eternal City was the very centre of Catholicism and the Old and Young Pretenders were very much feted in Rome. Almost without exception the British Grand Tourists were Protestants, fearful of the Stuarts.

Having reached Naples and taken in the Antique remains of Pompeii and Herculaneum, the young tourist turned round and headed for home by way of Bologna and Venice, then over the Alps to Switzerland and Germany and finally back to England by way of Holland.

Venice had no Antique remains (it did not even exist in Roman times) and there was not a lot in the way of Italian Renaissance art such as could be found in Florence. The principal appeal of Venice was the charm of its easy-going way of life. It was the place to indulge an appetite for wine, women and song without feeling overly guilty, and that is still one of the attractions today. In addition, there were contemporary and

favourable comparisons to be made, which were of particular appeal to British temperaments. La Serenissima had been the principal old-world maritime trading power and empire. Britain herself was consciously in the process of becoming the principal maritime trading power and empire of modern times. The Palladian mansions which prosperous Venetian nobility had built in the countryside along the Brenta Canal suggested a model that the British gentry and nobility soon repeated in the English countryside.

In the 1720s and 1730s business could not have been better for Canaletto. Consul Smith, the English diplomat resident in Venice, acted as his agent. Commissions flowed in. However, fashions and politics are fickle. The relentless demand for tourist souvenirs pushed Canaletto into overproduction. He began to simplify his technique and eventually turned it into a formula which studio assistants could replicate without too much difficulty. The near-decade-long War of the Austrian Succession in the 1740s made travel less appealing and easy, and the number of visitors arriving in Venice diminished. At the same time, patrons and collectors began to weary of Canaletto's easy-on-the-eye, and increasingly formulaic, *vedute*. Canaletto's artistic and money-making ability, if not exactly finished, certainly took a knock. He tried new subjects, such as views of Rome, and risked a lengthy sojourn in England to paint topographical views of London and the country houses of some of his clients. However, the energy and originality had gone and increasingly his work looked mechanical and stylised. Indeed, there was a rumour circulating at the time that these later works, because they look so routine, could not possibly be by the great Canaletto who had such genius. They must be the work of an imposter. It all goes to confirm that if you are going to have a Canaletto you must have an early one, preferably from the key moment when, in his early 30s, his meteoric talent and ambition were in full flow, and he was revelling in his intoxicating powers of invention and artistic skill.

The Arrival of the French Ambassador is arranged as if it were a scene from a play or an opera. In front of the grand panoramic backcloth showing Venice in all her glory, there is a cast of many dozens, and centre stage, as if singing a duet, are the French Ambassador and his Italian host.

We would seem to have the best seats in the centre of the front row of the grand balcony of the theatre (where the royal or presidential box is usually situated), to look down and appreciate this splendid production. All that is missing is the music – although, on one of the afternoons when Carolyn and I were in the Hermitage in 2017, a choir and orchestra rehearsed a Mozart Mass in a gallery adjacent to that containing the Canaletto. It was a truly sublime and unforgettable experience, which succeeded in elevating all the senses.

Canaletto's views of Venice are never slices of visual reality like a photograph. Those who have studied his scenes closely and juxtaposed them with the places they are supposed to be, have shown how buildings were edited to change their appearance, removed altogether or sometimes inserted into a new location. Sunlight was made to fall onto a corner of the square where no such light has ever fallen in reality because, for example, the corner is north facing. We know he used mechanical aids like the camera obscura to assist accuracy and rapid working. He made detailed and accurate pencil sketches but shifted his viewpoint from time to time to give a slightly different angle of the same building, or to open up a view or a hidden corner. He would then combine these different viewpoints seamlessly in the final painting to show more than the eye would actually be able to see. Sketches were made of single figures or groups that had pleased him, and these too were incorporated. The final result was a brilliantly executed jigsaw of different pieces which are locked together to form an uninterrupted and utterly convincing whole.

No aspect of the theatrical scene painter's art is more devilishly cunning than that of perspective. Rarely does Canaletto use just a single fixed-point perspective: rather he combines more than one, and nowhere does he do so more brilliantly than in this painting.

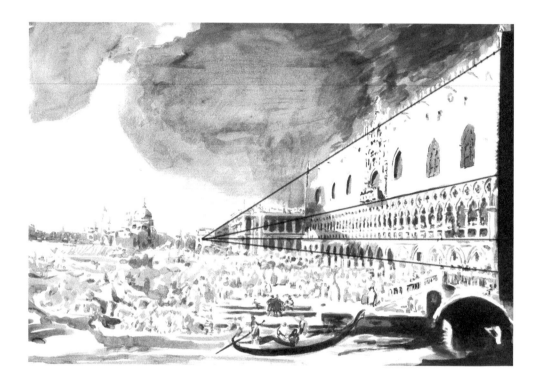

If you draw in the perspective lines which are presupposed by the facade of the Doge's Palace you will see that they meet, as they should, at the subtly emphasised white building in the middle distance. It is thrilling to discover its precision for the first time, and the sheer audacity of it never ceases to excite me. The left-hand side of the picture has a different perspectival arrangement. But that is only the beginning of the theatrical virtuosity learned at his father's knee.

It is when you start to divide the picture up into halves, thirds, quarters, sixths, eighths and twelfths that you begin to see what an extraordinary and meticulously planned composition this is. Composition is the right word for there is something musical in which he sets a 3/4 rhythm against a 4/4 rhythm, maintaining a steady beat whilst allowing sky, light, crowds of people, individuals, architecture, water, to soar like

visual operatic voices, or meld like a choral ensemble, each with its own exacting part, but all in perfect harmony, and all keeping to the rhythm of the carefully orchestrated underlying structure.

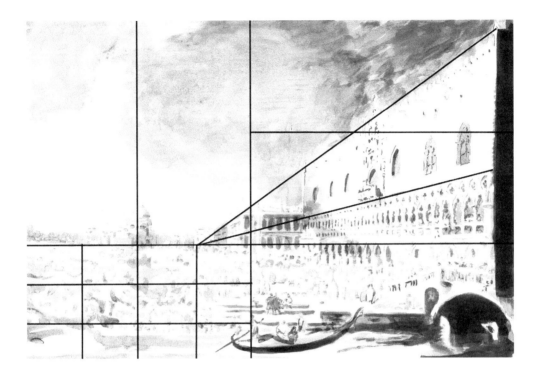

The masterstroke, and brilliant sleight of hand, is the way he uses this geometry to place his patron, the Ambassador, at the very centre of the stage.

Even then, for me, he still has one last entertaining trick to play. His crowd seems to have an unpredictable flowing movement as it spills like a swarm down the steps of the bridge on the right, onto the Molo, echoing the arbitrary rocking of the boats on the water.

By contrast the official procession moves in the opposite direction, towards the Doge's Palace, at a disciplined and measured pace.

I am sure that one of the reasons that I am tempted to keep going back again and again to take another look is to see if, as in the game of Grandmother's Footsteps, I can catch one of the gondoliers or a member of the crowd in actual motion.

Few are the artists who have been able to paint Venice convincingly. To my eye, most have failed. Monet could not do it, nor could John Singer Sargent. The much underestimated, short-lived, Richard Parkes Bonington succeeded, as did Whistler in his pastels and etchings. Canaletto was the supreme master who has only one real rival, J.M.W. Turner.

Guardi only occasionally captured the true essence of the city itself, but the lonely and melancholy moods of the lagoons were well served by his art. His subdued silvery palette and flickering feathery brushwork were ideally suited to the mournful sweep of uninterrupted expanses of sky and water with only a fleeting human presence. In contrast, Canaletto was at his best with the boisterous ebullience that gripped the city when there was a Regatta, a Feast Day or a Celebration. He perceptively observed the exuberant crowds and the way direct and reflected light played across buildings. He noted how many facades were designed to make the best use of the never stationary daylight.

Light is like a butterfly, and you need a clever architect to design a window embrasure, a doorway or cornice in such a way that it will capture light, play with it, allowing it to tremble as if it were a fluttering

butterfly cupped momentarily in the hands. Canaletto was able to capture that butterfly and by painting it as he did, preserve that precious quivering moment for ever.

Wander as we might around the Piazzetta, and up and down the Riva degli Schiavoni we will never find the place where Canaletto stood or sat to make the preliminary drawings for *The Arrival of the French Ambassador*. His scene is pure fantasy, nothing but theatrical illusion. The elevated viewpoint, the front row of the Dress Circle in which we sit so comfortably to view the spectacle, does not exist. There is no balcony in the whole of Venice that gives such a view over the Molo and up the Grand Canal. The only possible way of seeing it, more or less as Canaletto shows it, would be from a hot-air balloon hovering over open water.

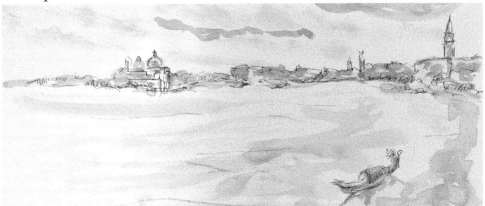

There is a window in Venice which has a very distant view not dissimilar to the one Canaletto created. This I do know, but it is about a mile away down by the Arsenale. We spent a week of our honeymoon in the delightfully, at that time, inexpensive and romantically tatty Pensione Bucintoro on the Riva San Biagio. We were given the honeymoon suite on the first floor, from which we could look out of a window onto that view. The minutiae of the geography are such that no other building in Venice has it. Years later we stumbled on the view again in a tiny pastel sketch by Whistler that was included in an exhibition in London. It was unmistakably 'our view', but how did Whistler come by it? The answer turned out to be that when he retreated to Venice, dejected and penniless, after the disaster of his libel case against Ruskin, he stayed in the very same pensione – then called the 'Casa Jancowitz', a legacy from

the time when Venice was under Austrian rule. He must have stayed in the same room, and I am inclined to think from what I remember of the lumpy bed, that we may well have rested on the very same mattress that he used. Indeed, I cannot also help wondering whether *The Arrival of the French Ambassador* might have been an influence on the young Whistler? When he was eight years old his father, who was an engineer, had been recruited by the tsar to design a railroad system for Russia, and the Whistler family went to live in Saint Petersburg. At the age of eleven he had enrolled at the Russian Imperial Academy for Arts. Whether he saw our picture and whether it influenced him, is pure speculation on my part, but it is not improbable, and it is a good thought.

This might be the moment to retire to the Piazza San Marco and indulge in a wickedly overpriced aperitif. As we do so we might ponder, as so many have done over the centuries, on the avarice of the Venetians, the gullibility of tourists, the appealing romantic theatricality of Venice, and the fate of empires.

Canaletto could look back two centuries to the high point of the Venetian Empire and her greatest painter Titian, just as we can look back similarly to the high point of the British Empire and her greatest painter, J.M.W. Turner. In her heyday Venice was the geographic crossroads of world trade. Her commercial fleet which criss-crossed the Mediterranean was the largest in the world. Venetians had a substantial land empire which included Cyprus and Crete, Trieste and the Dalmatian Coast. In Italy the empire stretched west almost to the gates of Milan, and south almost to the gates of Florence. They traded in goods of any kind, and even their painters were part of the export trade. Titian saw no point in starting a painting unless there was a firm contract and money on the table. His clients were the princes, monarchs, and the highest echelons of European nobility so he was probably wise to ask for their money up front. He was too innovative and original for Venetian merchant taste, which was very conservative, which is why the finest Titians are not to be found in Venice itself but in Madrid, commissioned by Philip II. By the same token the best arrays of Canalettos are in the Royal Collection and

in the country-house collections of Britain. It will come as no surprise, therefore, to realise that *The Arrival of the French Ambassador* was to all intents and purposes painted for export.

Within little more than half a century from its creation, and within a few decades of Canaletto's own death, Venice, La Serenissima, which had stood firm and proud for over 1,000 years, was consigned to the dustbin of history, deliberately and callously destroyed by Napoleon as part of his determination to subjugate the whole of Europe to his will, imposing regime change and nation building on countries and peoples who did not want it.

As Napoleon's armies marched to take possession of the city and subdue the last vestiges of her empire, the final Doge of Venice, in his palace and in front of his senators, renounced all the panoply and powers that he had inherited from his forebears. Not a shot had been fired. It was an act of craven cowardice, and then in an act of equally unforgivable cynicism, Napoleon, having taken possession, burned all the state barges and sold the remnants of this once-great empire to Austria for a pittance simply to give himself a negotiating card which in the end he never used.

For over half a century Venice was under foreign rule and was then folded into the hastily cobbled-together new kingdom of Italy, a further political subjugation which the Venetians resented as much as their annihilation by Napoleon. Thus, in *The Arrival of the French Ambassador* we have one last farewell glimpse of what Venice once was, and as if with foreknowledge of what was to come, Canaletto painted a menacing dark storm cloud hovering over the Doge's Palace. It is like the last sumptuous, splendid final act of a grand opera. We watch at a distance from our seats in the auditorium. We know that the curtain is about to come down, and the unfolding tragedy is made all the more intense and poignant because, knowing what will happen in the end, we can only watch in impotent silence as the characters on stage proceed uncomprehendingly towards the final calamity.

Painterly Reflections by Gino - Canaletto

I always found Canaletto to be a painter of postcards until I came face to face with his painting. When he gets it right, as in this painting, the joy of experimentation and pursuit of rhythm and line is exhilarating. I sense Canaletto had a personal attachment to this work and that he set out to make a statement of his abilities to attract similar commissions.

His background in theatre design allows him to construct a painting that is neither didactic nor simply a record. Like a good documentary filmmaker, he brings alive the momentary aspects we all share when attending a celebratory event such, as the endless queuing, the boredom, the weather, the fight for refreshments, and parade of costumes.

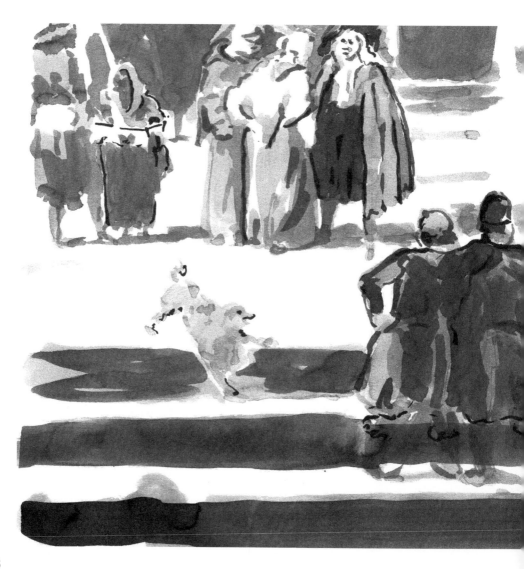

I am the opposite of Canaletto. I like to draw and paint freehand because I find the rigidity of using a helping hand like a camera obscura gets in the way. Early in his career Canaletto experimented with many painterly approaches, with fluctuating results. He then found that the technology of the camera obscura helped control those fluctuations. It helped him to plan his complex composites. In this painting, you can clearly see his meticulous attention to detail and his need for complete accuracy. His use of a combination of Venetian ground and grey imprimatura helped him achieve the wonderful greys, blues, pale yellows and golds, which were perfect to describe the cool Venice light in his paintings. He used a stylus to mark the architectural outline into the Venetian ground. After refining the details, he then painted the boats and figures over the architectural background.

Rather than be satisfied with strict accuracy of detail, Canaletto has been spurred on to invest time in experimenting and applying his imagination. This enlivens the brushwork and the feeling of movement in the painting. The dialogue between meticulous detail and a more expressive approach makes this painterly adventure truly joyous.

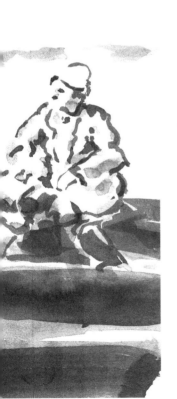

Canaletto is inexorably linked to my childhood. Five of his prints lined the stairway wall. My father was in the navy, and they were his. He was often drunk and physically abusive to my mum who, though battered and bruised by him, was deeply loving. She protected and supported us, giving us a sublime childhood when he was not around. After leaving the navy my dad traveled away for long periods to other countries for work contracts. This temporarily lifted the burden of living with an oppressor. Then he would return, bringing home another Canaletto print.

One: Number 31 (1950)
by Jackson Pollock is in
MOMA, New York

After Pollock
ink wash on
watercolour paper

Jackson Pollock
One: Number 31, 1950

Jackson Pollock

One: Number 31, 1950

I have always believed that the true purpose of art is to make the world a better, more interesting, more humane and more beautiful place. I admire those who share that philosophy, and who without thought of personal gain or advantage have the courage and tenacity to strike out in a new direction, build on the past and respect it, not seeking change for change's sake, but searching for ways to do things better and risking failure in order to achieve their ideals.

I appreciate that is a bold statement to make and that not everyone will agree with it. For some it might seem foolishly utopian, unrealistic and unobtainable. Nonetheless, I would argue that the young Velázquez, Fra Angelico and even the young Canaletto were inspired by such a belief, and that in their heart of hearts they either remained faithful to that spirit until the end of their days or regretted when they departed from it.

Paradoxical as it may also seem, that belief caused me to become fascinated by the heroic chapter of modern art, at the centre of which is the generation headed by Picasso and Matisse. Consequently, I wish to suggest that our next meeting place should be New York in order to visit the Museum of Modern Art (MoMA). Even if you are among the doubters about the merits of modern art, please bear with me and come on the journey. I will accept the challenge to test my belief to destruction, and in so doing ask you to explore with me an archetypal abstract painting, Jackson Pollock's *One: Number 31, 1950*.

As I was starting to discover the pleasures of listening to music, and long before I began to take an interest in looking at works of art or had even heard of Jackson Pollock let alone set eyes on his huge-scale multilayered drip paintings, my grandmother planted a musical and poetic seed called 'Transatlantic Lullaby'.

> *Soft Manhattan evenings fall*
> *A velvet dust envelops all*
> *On Hudson River, distant tugboats cry*
> *Ship to ship and shore to shore*
> *The waters make a shining floor*
> *And hum a transatlantic lullaby.*

One of her favourite records was this song, which, at my request, she played over and over again on her radiogram. The singer was Turner Layton, a black American crooner who was at the height of his fame in the 1930s. He seduced his audiences with a soft baritone voice that was as smooth and as soft as silk, his accent bizarrely English and upper-crust. His fingers caressed an enviable cascade of golden harmonies and trills from the keyboard. I soon knew all the words of 'Transatlantic Lullaby' by heart and seven decades later can still remember the words and the tune. It was a song of irresistible images.

> *The sky is silky dark, it's cool in Central Park*
> *The trolley cars go clanging past*
> *A busy day is done, the lights fade one by one*
> *And Broadway goes to bed at last*
> *Tomorrow seems a distant dream*
> *And still the rocking waters gleam*
> *And hum a sleepy transatlantic lullaby*

I knew that when I grew up, I wanted to go to New York and live the dream. Indeed, I still hanker after a career as a suave piano bar performer in a white tuxedo. My grandmother had never been to America herself, but in my childish imagination I had envisaged her sailing to America

in style on a transatlantic liner. The sober reality was that she had been no further than the Criterion Theatre in Hull to hear Turner Layton play and sing when he was doing one of his pre-Second-World-War round-Britain tours.

In its heyday, the 1930s, 1940s and 1950s New York epitomised two things: style and money. They were not always easy bedfellows and eventually money and greed triumphed over style. 'Transatlantic Lullaby' was a celebration of the smart, classy, chic elegance which is the essence of style. When we plan our visit to New York I would like to suggest that we choose a means of travel that emphasises style rather than money. Flying Economy Class is not stylish, and although flying First Class is ostentatious, it is a waste of money. Why spend up to £500 per hour for the seven-hour flight from London to New York lying flat out in a claustrophobic glorified cigar tube when for half that money you can go to New York and back by transatlantic liner, seven days with full board and more entertainment than you can absorb on the way over, and the same for another seven days on the return journey? I have crossed the Atlantic backwards and forwards over 100 times, twice on a transatlantic liner. Believe me when I say that the journey by ship is preferable. To leave downtown New York standing on the upper deck of *Queen Mary 2* as the stately liner passes under the Verrazano

Bridge with a mere six feet to spare, anticipating a pre-dinner cocktail, watching the skyscrapers of Manhattan silhouetted against an evening sky receding slowly into the distance, is an experience not to be missed.

When we get to New York may I suggest that we stay on the Upper East Side? It is the area of Manhattan that I know best and where for over 20 years I used to stay on my brief working visits. In 1977 Christie's had inaugurated their new auction room on Park Avenue. They had taken a lease on an iconic New York landmark building, Delmonico's Hotel, situated on the corner of 59th Street. Delmonico's was a famous New York institution that underwent many rebirths in its long history, one of which was to establish a hotel on Park Avenue, opening in 1928 almost opposite that palace of art deco modernism, the Waldorf Astoria. Between them the two hotels epitomised the style, luxury and carefree hedonism of the jazz age.

Delmonico's Hotel did not survive the Wall Street Crash or the Great Depression. By the 1970s the building had become unloved and dilapidated. Christie's, with uncharacteristic opportunism, took a lease on several floors, established a presence in New York to rival Sotheby's and turned Delmonico's ballroom into a modern auction room. In the first week of January 1978, I had started employment with Christie's auction house in London to establish a new venture, the Christie's Fine Arts Course. Two months later Carolyn and I boarded a crowded Pan Am jumbo jet (Economy Class) to visit New York for the first time, in order to interview a selection of the dozens of Americans who had applied for the year-long programme. When we arrived, we discovered that the conversion into offices was still taking place, and for many employees their desk was an old bathtub covered with a sheet of plywood in a pre-war bathroom, their office chair being the adjacent toilet seat with a cushion on it. I loved every minute of the makeshift improvisation.

Christie's had also retained several apartments for use by out-of-town employees, and by planning ahead it was possible to be allocated one of these for a visit of a week or two. One of the great advantages of staying at Delmonico's was that many of New York's finest museums and art collections were within walking distance or a short hop by subway, bus or taxicab: the Metropolitan Museum of Art, the Frick

Collection, the Guggenheim Museum, the Whitney Museum, the Pierpont Morgan Library and, nearest of all, MoMA. Soon after I retired from the firm in 2000 and to my regret, Christie's moved their base downtown to 49th Street.

To give you a taste of the true New York I will take you on a (for me nostalgic) walking tour of some of Manhattan's greatest pre-war buildings. First, we should go to that monument of art deco with its radiant stainless-steel decoration, the Chrysler Building. Completed in 1930, it was briefly the tallest building in the world. A year later that honour was captured by the Empire State Building, which retained it for decades. We must also take in the group of pre-war skyscrapers that constitute the Rockefeller Center. If ours is a winter visit, we shall have to pause to watch the ice skaters on the outdoor rink. We should also arrange for tickets at Radio City Music Hall. With luck we will be able to take in a performance by the high-kicking female precision dancers The Rockettes, whose routine is little changed since they first performed in 1932. In our meanderings we should also take note of Central Park, Broadway, Carnegie Hall, the post-war Seagram Building which is the epitome of the minimalist International Style that was the successor to art deco, and finally end up at the famous Oyster Bar in the monumental and elaborately decorated Grand Central Station.

I will try and arrange for us to sit in a quiet corner so that over dinner we can discuss how best to spend a day at MoMA, as well as plan a strategy for looking at and sharing with the minimum of distraction Jackson Pollock's *One: Number 31*, 1950. MoMA is devoted principally to the art of the twentieth and twenty-first centuries. Its permanent collection contains over 200,000 works, and it attracts well over two million visitors a year. Indeed, it was the first museum anywhere to devote itself entirely to modern art. Although it has spawned many imitators it remains the largest and most influential museum of its kind in the world. One of New York's top tourist attractions, it is always busy and crowded – up to 10,000 visitors pass through the museum every day. Our best strategy may be to buy an annual membership pass which will allow periodic early morning access at 9:30 am before the crowds arrive at 10:30.

I do not want to pre-empt the pleasure of looking at Jackson Pollock's painting at first hand, but a few preliminary observations might be helpful. *Number One*[2] is one of the largest paintings ever created by human hand. That is a big statement and requires some qualification. It is nearly 9 feet high and over 17 feet wide (269.5 cm by 530.8 cm), i.e. 154 square feet or 17 square yards, as big as if not bigger than the floor area of most people's living rooms, almost twice as big as Velázquez's *Las Meninas,* five times the size of the central panel of Fra Angelico's *The Cortona Altarpiece,* and three times the size of Canaletto's *The Arrival of the French Ambassador in Venice.* Nearly every other painting that competes in terms of size was either created to adorn the ceiling or walls of a specific pre-existing room, was a specific commission by a patron, or is a collaboration by several painters. For example, Picasso's *Guernica,* which is slightly larger, was commissioned by the Spanish Republican Government for the Spanish Pavilion at the International Exhibition in Paris in 1937, and Picasso intended it to be a large-scale public statement and protest. *Number One* was an act of purely personal and private creation.

[2] I find the unnecessarily complicated official title *One: Number 31*, 1950 to be a distraction so I shall refer to the painting simply as Number One. Pollock did not want wordy titles for his paintings so he gave them numbers which he thought, since they are detached and neutral, would force people to look at his works for what they were: pure painting.

All abstract art is arguably an acquired taste, and the first encounter with any abstract painting can be baffling. Above all, it is an art that requires context, and a patience and a willingness to be experimental and open in response. It is also high risk, and most abstract art, although well-intentioned, fails to fulfil its aspirations. Figurative art is nearly always accessible on a very basic level because it offers the pleasure of the simple recognition of things seen in real life. With abstract art it is necessary to abandon any hope of recognition and let the imagination wander. For some reason this is easily and instinctively done with music, but with the visual arts it seems to be more difficult.

My point simply is that when listening to music I suspect that I, like many people, have no difficulty in letting my mind's eye saunter where it will, allowing the senses to open up, venturing on who knows what dreamlike journey, and conjuring up all sorts of images. It takes time to let the experience happen and music of course provides that time, 50 minutes in the case of Beethoven's *Pastoral Symphony*. The visual arts do not provide time in the same sort of way, but I would like to suggest that if you allow them a sufficient interval, abstract paintings can release through the eye the same sort of imaginative experience that music, which is just as abstract, delivers through the ear. Both require an effort to leave the physical world and the chatter of words behind. I entirely accept that it is not easy. I know from my own experience that it took me a long time to acquire the ability to do it. All I can say is try it and see if it works for you. It will require great patience and a willingness to suspend disbelief, but the potential rewards are worth it.

Number One is displayed in a plain white cube of a gallery on the fourth floor of MoMA. Once there, it is important to resist the natural inclination to stand back from the large canvas to see it as a complete 'thing'. Pollock himself wanted you to stand close so that the eye and mind would be completely engulfed by what is happening on the paint surface, and the edges or limitations of the picture as a physical entity would disappear. A postage-stamp-size reproduction of *Number One* floating in a sea of words in a book is, I regret to say, quite meaningless. At best it is an aide memoire. The crucial thing is the experience of being in front of it.

There is, of course, nothing in the painting to recognise and no object or person to identify, but there is still plenty to see, for example how rich and dense the interwoven layers of paint are, and how the underlying bottom layers of dripped paint are matte because they have soaked into the canvas. As the layers build up one on another, they become glossier because fresh paint is not absorbed into paint that has dried. It is also possible to notice areas where raw turpentine has been poured directly on the canvas to dilute the paint, and places with wrinkled skins of paint that have come straight from the lid of the paint can. Pollock used industrial paints and enamels on purpose, not just because they were relatively inexpensive and 'unarty', but because they dried quickly, within hours.

As we start pointing things out to each other we will discover places where paint has been apparently added at the last minute, either flicked or dabbled on with a soft brush. Even though the canvas is so enormous there is unexpected attention to fine detail. You can see that he has taken conscious decisions about colour – the juxtapositions of blue and green being of great importance – and equally how vital are the open intervals of bare canvas. In the same way that Matisse would deliberately leave open spaces in his paintings where the underlying canvas would show through white and untouched, in order, as he said, to 'allow the colours to breathe', so Pollock granted his skeins of paint bare places where they could display their own freedom.

You may already be aware that whereas most artists paint with their canvas set up vertically, Pollock rolled out a single piece of raw unprimed canvas across the floor of his studio and worked on it as it lay horizontally flat. No painter had ever done such a thing before. The popular notion, which I once shared, that Pollock worked by standing in the middle of his canvas dripping and dribbling paint all around him in a more or less random manner in a trance like state, and that his drip paintings were examples of what art historians are pleased to call 'automatism', is simply untrue. Once you start to look carefully at his paintings and examine them in detail it is possible to see just how false such a claim is. He was careful to work within the confines of his

cotton rectangle, to go out to the edges, but rarely go over them. Nor did he ever stand in the middle of these enormous paintings. Had he done so there would be footprints! He worked from the sides inwards towards the centre and might only occasionally venture by foot onto the cotton surface. The photographs show this, and it is also possible to work it out here from the patterns of the lines of paint. In other words, Pollock's method in his drip paintings was very calculated and cerebral. Every stage was carefully considered, and many conscious decisions were taken.

There seems little doubt that Pollock intended *Number One* to be displayed hanging vertically, and it is possible to see this. There are drips of paint running down the canvas under the pull of gravity. The likely explanation is that he took his canvas from the floor and pinned or tacked it to the wall of his studio whilst the paint was still wet, or worked on it later when it was vertical.

When Pollock painted *Number One* there was no stretcher, the invisible wooden frame onto which picture canvases are stretched and pinned to ensure they form a taut flat surface suitable for display on a gallery wall. It was simply a single piece of rough cotton material, straight from the roll. Later, when it became a collector's item and a commodity, the canvas was attached to a stretcher. However, that meant turning the edges of the canvas over the stretcher frame and nailing those edges to the back of the frame, i.e. losing from view a good two to three inches on all four sides. Does that matter? It is a good question. In one sense no, for it had to be done to make the enormous 'thing' manageable and fit for display. On the other hand, it does matter for whereas now there are threads of paint which appeared to flow over the edges of the canvas, once they did not.

I shall take great pleasure in pointing out a detail that I suspect scarcely one in a thousand visitors will ever notice. It is the embalmed corpse of a house-fly. Accidentally trapped in a puddle of liquid paint, it had struggled vainly to escape, failed to survive, and by dying achieved immortality, preserved forever as an element in *Number One*.

This may be a good moment to take a break in one of MoMA's many cafés so that I can explain how I came to discover the dead fly, and for us to discuss Jackson Pollock the man and the artist – 'Jack the Dripper'.

In the spring of 2013 Carolyn and I were in New York. *Number One* was not on public display as it had been removed to MoMA's conservation studios. However, it was our good fortune to be invited to have a close look at it there, and for over an hour, with Irving Sandler – who knew more about the Abstract Expressionists than anyone else then alive – and two conservators, we had the painting to ourselves in peace and quiet, to look at, contemplate and think about. Very few words were spoken. In the undisturbed presence of *Number One* they were unnecessary.

The painting on its stretcher was raised up onto easels so that it was possible to walk round it and see the selvedge of the canvas (the edge of a woven fabric finished so as to prevent fraying), demonstrating that Pollock had used the full width of the canvas without trimming it. It also showed how he took his trails of paint to the very edge of his canvas, but never over the edge. We could see too that where the edges of the canvas had wrapped round the stretcher and were thus protected from

light and atmosphere, the cotton was still very white and had not dulled to the light tawny colour which is now the visual background to the painting. It demonstrated how much sharper, crisper, more vivid, more electrifying, the overall appearance must have been with the picture when it was first painted.

When the restoration was complete the curators did, briefly, lay it on the floor of the studio to see what it would look like – but they did not go so far as to remove it from its stretcher. They discovered, that on the floor it appeared much smaller and more intimate, and that the rhythms in the trails of paint were much more apparent, as were the open spaces of raw canvas which provided breathing spaces for the interwoven skeins of paint. I wish I could have been present when they laid the painting flat, as I also wish you could have been present on that visit to the conservation studios rather than receiving my second-hand account of what we saw and experienced.

Jackson Pollock was born in 1912 in cowboy country, Wyoming, the youngest of five boys. His father was a shiftless, abusive and unsettled man who took to the bottle and who was constantly on the move seeking what work he could get as a farmer and surveyor, dragging his family with him, finally reaching California, where he abandoned them. Pollock was then in his teens. His mother, who stood by her sons and coped with these trials, was a fierce Presbyterian of Irish descent, but not much given to overt demonstrations of love and affection. The family member whom Pollock most admired was his elder brother, Charles, who left home early to go and study art in New York. His brother nearest in age also became an artist. Pollock followed their example but with no great sense of direction or purpose and went to live with Charles in New York.

Out west he had adopted a romantic, even effete persona, with long hair and a professed interest in mysticism. In New York he chose to play the chain-smoking, hard-drinking, monosyllabic tough man. Painfully shy and without any natural talent for anything, he was never capable of rising above the adversities of his childhood but instead, even at an early age, sought refuge in alcohol, anger and depression. Throughout his life he required constant support

financially and emotionally so as to keep going, often through the sacrifices of his mother. When, having achieved fame and fortune, he had the chance finally to reciprocate, asked by his brothers to support his ailing mother, he refused out of hand.

Although his early figurative work has a certain raw energy, it is undistinguished and derivative from European artists such as Picasso. Had he died at any time before 1949 he would scarcely merit a footnote in the history of art. What he is remembered for are the 'drip' paintings that he produced between 1949 and 1954. For one short five-year period the seemingly impenetrable, stifling black clouds of unhappiness that

were at the heart of Pollock's persona parted to allow him to be bathed by a shaft of genuinely imaginative and creative sunlight. He had the good fortune to be discovered, loved, nurtured and taken in hand by a remarkable woman who was herself a painter of some talent. Lee Krasner sought him out, believed in his latent abilities, and supported him in spite of everything. Realising that if he stayed in New York, he would drink himself to an early and anonymous grave she gave him an ultimatum: they must marry and remove themselves to the countryside. He acquiesced.

In the winter of 1945/46, when Pollock started to earn a modest income from sales of his paintings and with a loan from the pioneering and rapacious dealer Peggy Guggenheim, they purchased a derelict property in a remote part of Long Island. With no near neighbours, no friends, no transport other than their legs, no heating, no electricity and only cold water, but with a view of the ocean, they might as well have been marooned on a desert island. Together they made the unpromising

house habitable, planted a garden and cleaned out a dilapidated barn to turn it into a studio. Pollock stopped his binge drinking, and for the first and only time in his life, came to his senses.

It was on the floor of this barn that, almost out of nowhere and for no cogent reason other than, perhaps, the discovery of peace of mind, he first started to drip paint onto his canvases. He sustained the activity for five years until the New York journalists and dealers sought him out. He was very photogenic with his tough 'macho' image. His 'drip' technique was also eye-catching and headline grabbing, and the post-war New York art world was ready to flex its muscles. With honeyed words and alluring promises of fame and fortune they tempted him back to the big city. Once there, he abandoned his drip paintings, reverted to his previous derivative style, and resumed his drinking and womanising. His marriage fell apart. Lee Krasner left him and went to Paris. In August 1956, aged 44, fuelled with alcohol, he crashed his Oldsmobile convertible into a tree, killing himself instantly by breaking his neck. One of the two young women who were with him as his passengers also died. The other was thrown clear and survived. Lee Krasner returned

from Paris to take charge of his affairs and his reputation. Within four months MoMA had put on a memorial retrospective exhibition of his work. He had been received into Valhalla.

MoMA is one of the most influential and powerful art institutions in the world. Just as Washington and the Pentagon try to remain in control of and dictate the narrative, future direction and priorities of the international political order, so New York and MoMA effectively dictate the narrative and fashions of the world of modern and contemporary art. Consequently, I would like to suggest that we might spend the rest of the day exploring the institution, the collections and the building, and asking how and why it has achieved such a dominant position.

MoMA's exhibition spaces are arranged over six floors. At the top of the building is a space devoted to special exhibitions, i.e. those topics that it wishes the public to engage with and the artists that it has decided are worthy to belong to the international elite. On the next floor down is painting and sculpture from Impressionism to Surrealism, i.e. MoMA's selection from their own permanent collection of what they regard as the most important artists of the period 1880-1940. Essentially this is the Parisian avant-garde, starting with Cézanne and van Gogh. Here, Picasso and Matisse hold centre stage. The fourth floor is devoted to the art of the 1940s to 1970s, which is essentially American art starting with Jackson Pollock and ending with Andy Warhol. The third floor is devoted to special exhibitions, and the second floor displays a selection of artists from the 1970s to the present day that MoMA has chosen to add to its permanent collection. Any artist or movement that does not fit MoMA's chosen narrative is, to all intents and purposes, sidelined. Every artist with serious ambition living and working today knows full well who and what sort of art is included among this elite and would like to be part of it. To achieve a one-person exhibition at MoMA is to be granted apotheosis.

MoMA always had a very specific and ideological agenda. American collectors had long been attracted to modern European art. Their taste for Impressionist and Post-Impressionist works had been widespread from the very beginning and they naturally moved on to the French avant-garde movements such as Fauvism, Cubism and Surrealism. Pioneering came naturally to them. In 1928 seven rich collectors, mainly society ladies from the Upper East Side, announced they would establish and pay for a new institution to be called the Museum of Modern Art in order to preserve and display what they considered to be the best of the art of the present day. They were so motivated because the prestigious Metropolitan Museum was reluctant to acquire modern art. MoMA's origins were surprisingly modest. It opened nine days before the Wall Street Crash in a few rooms in an office block on 5th Avenue, but from the outset it attracted such significant interest and visitor numbers that it soon outgrew the humble original premises.

After several interim moves, in 1939 MoMA established itself permanently on 53rd Street, and its opening exhibition was called *Art*

in Our Time. MoMA's trailblazing building in the Bauhaus style was the epitome of modernism and a landmark in the establishment of the International Style. Fortunately, in the late 1970s and early 1980s it was still in that same pioneering building. I was so taken with it and its harmonious atmosphere and the perceptive displays of works of art that I was willing to pay a hefty subscription to become a member for the pleasure of going there in my spare moments as well as lunching in the Members' Dining Room.

Sadly, from the mid-1980s greed and money took precedence over style. The integrity of the pre-war building and its displays was effectively sabotaged by the construction of a 56-storey tower with luxury apartments as an extension to the building. The Members' Dining Room and much else was demolished.

Another regular visitor to MoMA in his early years was the distinguished writer and novelist John Updike. A man of great visual sensitivity – he had toyed with the idea of being a cartoonist before he took up his literary career and had studied at the Ruskin School of Art in Oxford – he was also a perceptive art critic. He thought that the Trustees had destroyed MoMA as a place of quiet contemplation and civic pride and turned it into a luxurious cash-generating tourist trap.

Worse was to come. At the beginning of this century the museum underwent a complete rebuild, not so much for aesthetic or artistic reasons (although their relentless acquisition policy meant they were constantly short of space), so much as a commercial real-estate opportunity to acquire more land and build more luxury apartments skywards into the open space above. Updike commented that the new building 'has the enchantment of a bank after hours, of a honeycomb emptied of honey'. For me the experience in MoMA is now not that much different from a hectic, restless shopping mall, with the artists turned into 'brands'.

Although I actively dislike the current building on 53rd Street and consider that the Curators and Trustees have lost the plot, I am still willing to spend an afternoon there. Personally, I shall be mainly on the fifth floor reacquainting myself with masterpieces such as Matisse's *The Red Studio*, Picasso's *Girl before a Mirror*, or Fernand Léger's *Three*

Women, and in the company of artists who were motivated by beliefs that shaped my own about art seeking to make the world a better, more interesting, more humane and more beautiful place. You are entitled to ask therefore: in that case why am I so attracted to Jackson Pollock's *Number One*?

I am aware that nostalgia and childhood dreams about New York and America have something to do with it, but my reasons go deeper than that. Pollock's picture is firmly embedded in my cultural DNA. It is a work of art from the century into which I was born and in which I have mostly lived, and that is important to me. One of the dangers of a love of history is that it can become a means of escaping the present by finding refuge in the past, and I have seen too many colleagues in the art world disappear down that particular rabbit hole. In my view the principal purpose of history should be to inform the present and provide enlightenment and guidance for the future. For me, *Number One* is both a guide and a warning.

Number One was created when I was five years old, in my earliest formative years and developing the consciousness that is the essence of my personality and being. Jackson Pollock and I are branches of the same cultural and genetic taproot. Both our fathers were of Scottish ancestry, and both our mothers had Irish blood in their veins. We are both inheritors of that curious combination of romantic yearning, solitary stubborn independence, single-minded industrious inventiveness, monosyllabic dourness and observant dry humour which are the blessing and the curse of the Scotsman. If these traits combine well, they can manifest themselves as strong moral leadership, courageous tenacity, cautious diligence and a quiet, patient selfless concern for humanity. If they combine badly, they can manifest themselves as boorish intransigence, a selfish disregard of others, disparaging cruelty and the self-righteous pursuit of unrealistic and unobtainable dreams. Pollock and my parents were born within three years of each other. Although my family's comfortable middle-class settled upbringing was completely different from his, my mother and father did not have easy or particularly happy adult lives either. *Number One* is my reminder of the trials and tribulations that their generation had to cope with.

For me, the direct experience of a work of art is paramount. It is possible to talk or write about *Number One* simply as an artefact or document in the history of art, just as it is possible to talk about Beethoven's *Pastoral Symphony* simply as an interesting musical score or as a manuscript. However, to my mind, to leave either of them there misses the point of their creation and existence entirely. Beethoven composed his *Symphony* in order that it should be performed, listened to and experienced. Pollock painted *Number One* in order that it should be looked at with imagination and feeling. He too wanted the painting he had created to be an experience.

To exemplify what I am trying to get at we should return to the fourth floor to examine how MoMA's curators present *Number One* to their visitors. The gallery where it is on display is devoted to abstract paintings by American and European artists with the following written statement: In 1949 LIFE magazine published an article on the artist Jackson Pollock that asked, 'Is he the greatest living painter in the United States?' The American art world answered with a resounding 'yes' championing Pollock as an example of a brand new, American-born style of modern art commonly known as Abstract Expressionism. Having emerged during the Cold War – a period characterised by distrust between the United States and the Soviet Union – Abstract Expressionism functioned politically

as a symbol of democratic freedom and independence. Exhibitions of Pollock's work around the globe helped to spread this message.

As if in anticipation John Updike had already penned:

> The written word, and the mode of thinking that words shape still stands embarrassed before abstract art. What is it *about*? What is *happening*? The artists, quite rightly, spurn verbal explaining, claiming paint to be a sufficient vocabulary. . . Pollock painting is the subject of Pollock's paintings. Abstract Expressionism has the effect of glamorising the painter of making him, rather than the sitter or the landscape or the Virgin, the star.
>
> *(John Updike: Just Looking, 1981)*

MoMA will close its doors at 5:30, at which point we might treat ourselves to a quiet evening together in one of the small, intimate European-style restaurants that can be found lining Lexington Avenue on the Upper East Side. I am longing to ask what is your judgement on MoMA? I am equally sure there are questions you wish to ask me, one of which might well be 'Have your beliefs been tested to destruction yet?' I promise I will answer but will ask you to wait as there are other things that I need to get off my chest first.

It was at the old Tate Gallery at Millbank that I learned how to appreciate a wide variety of abstract art. The most instructive and influential examples were Rothko's abstractions with their floating blocks of soft, sombre colour. The Tate had received, as a gift from the artist, a series of large paintings that had originally been commissioned for the Four Seasons Restaurant at the top of the Seagram Building in Manhattan. Rothko eventually decided that the company of munching expense account diners who would not even bother to look at them, and who would at best regard them as high-class wallpaper, was inappropriate. Instead, he gave them to the Tate where they were hung together in a single room with low-level filtered daylight that subtly changed over time. That gentle, varying daylight, and with it a connection to the world outside, was hugely important. Hard, unchanging artificial light kills these paintings dead. I often made a point of taking visitors to that

darkened room to see what their reaction would be. At first the group, sitting on their little collapsible stools, would be noisy and chatty, jaunty with a 'what's all this all about, there's nothing to see!' attitude; but as they sat there (and it took about 20 minutes) their mood changed. The group became silent and thoughtful, and finally appreciative. Gradually with the changing light, the paintings worked their spell, conversation ceased and words became irrelevant. A sort of unspoken dialogue developed between the group and Rothko's paintings. Their reaction gave living validity to Rothko's famous dictum that his paintings were about human emotion – tragedy, ecstasy and doom – and those who saw them, or could verbalise them, only in terms of colour missed the point.

When I was on my metaphorical desert island with *Number One*, I thought long and hard about such matters. To get closer to the Pollock, instead of reading or listening to words (there are no books, lectures, access to the internet or another person's brains to pick on a desert island) I let my imagination wander. I dreamed of removing *Number One* from its stretcher and laying it on the ground of my desert island so that my relationship would be as near as possible to that of Pollock when he created it. In my imagination I then moved that large piece of canvas around my desert island to different locations. I wanted to see what it would look like on the flat dry sand of the beach, for it is claimed that Pollock was influenced by the Navajo Indians who created ritual

images by making marks and patterns in the sand of the desert, erasing them when the ritual was over. I envisioned leaving Pollock's canvas on the sand and watching the waves come in and lap backwards and forwards over it. Then common sense took over and I did not think that even I would quite have the courage for that. On the other hand,. . . on a desert island where a work of art no longer has any significance as regards financial worth, or cultural, historical or heritage value, with no one else to share it with, so that its only virtue is its own existence... why not?

I imagined taking it deep into the forest or jungle of the desert island and watching sunlight filtering through the leaves and branches, adding their own patterns to the picture. There are times when I have gazed at *Number One* on the gallery wall and in my wandering mind's eye have seen the imagery of branches and leaves, rhythmically dancing as they toss to and fro, opening and closing a kaleidoscope of shifting spaces to reveal the sky beyond, and I have heard the sighing of the wind.

In the dead of night I thought of moving it to an open space – perhaps back to the beach – so that the patterns on the canvas could look up, directly, at the starry canopy with galaxies and constellations above, and they in turn would look back down, for there are other times when my inner eye has seen the possibility of the infinity of celestial space among the trails of paint and open spaces, and my inner ear has heard the music of the spheres. A died-in-the-wool art historian or curator whose habitat is the library and whose visual material is photographs of works of art will have no idea of what I am on about or trying to express. Anyone who has tried to paint a picture, write a poem, play a Chopin Nocturne on the piano or master the art of French cooking will understand.

I promised to reply to your question as to whether my beliefs have been tested to destruction during our visit to New York. Over the decades my perceptions of Jackson Pollock, America and New York have changed radically, and to a certain extent they have altered in parallel. For a long time, I believed that anyone who could create a painting such as *Number One* must be fundamentally a decent human being. However my callow admiration for modern art, MoMA, New

York and America have become tempered by experience and age. The last time I was on the streets of Manhattan, a few years ago, I looked at the crabbed faces and petulant gestures of the passers-by and thought 'This is Sodom and Gomorrah'.

Although Pollock's generation had been nurtured on the art of Picasso and his contemporaries, the American artists that followed the Abstract Expressionists had a different set of ambitions and ideals. In tune with the aspirations of the new consumer society, they sought new role models. They ditched Picasso and glorified his contemporary, a Frenchman called Marcel Duchamp. Their chief guiding star was their own contemporary, Andy Warhol, who proposed that artists need no longer lead an impoverished evangelical existence trying to reform the world through art but were entitled to become rich celebrities and enjoy the hedonistic lifestyles of film-stars, businessmen, advertising executives and property developers.

Had Warhol's proposition gone hand in hand with a work ethic, moral philosophy and intellectual rigour which merited fame and fortune there would have been no problem. The wheels came off, however, when, from the late 1970s, his notions became wedded to those of Marcel Duchamp. Duchamp until then had been a curiosity figure, an offshoot of a minor movement called Dada. Duchamp had proposed that a work of art is essentially an idea or an intellectual exercise like a game of chess, and therefore requires nothing more than the having of an idea or making moves on a chessboard according to a set of preordained rules. Duchamp's proposal would have been fair enough as long as it had remained purely an end in itself, executed for the private satisfaction of the doer, with no demand for public adulation, financial reward or celebrity status. From Warhol's proposition about an artist's entitlement to riches and celebrity status, and Duchamp's proposition about art consisting solely of an idea, was born the seductive notion that an artist could aspire to become famous, and rich beyond the dreams of Croesus, not through some admirable work ethic or exceptional ability or through striving to create something that would benefit the rest of mankind, or even by doing anything creative at all, but simply by peddling an

idea that would titillate the desires of members of the consumer society. In fairness this notion was not unique or exclusive to the visual arts. It reflected a condition that was increasingly prevalent throughout all post-war Americanised consumer societies.

Americans have found it necessary to mythologise Jackson Pollock. Regarded as a modern secular saint, it does not matter that he was a drunken brute, or that the drip paintings by which he is remembered constitute such a tiny percentage of the total output. What matters is that he existed and that he fits the archetype of the authentic American cowboy hero. His shack on Long Island is treated as a shrine, and like the bones of Christian Saints, everything he touched and every spatter of paint on the floor of the barn are treated as holy relics.

For the commercial art world Jackson Pollock was more valuable dead than alive. Alive he was an unpredictable liability, and the weaknesses of his art and of character were all too readily apparent. Dead in early middle age, he could be presented as a promising life cut short, an authentic all-American genius, the casualty of the economic hardships of the Great Depression, of circumstances beyond his control.

How do the American art and academic establishments, who should know better than to take mythologies at face value, deal with Pollock? They cover him and his work in a thick torrent of verbiage, much as junk food is enveloped in thick sauces of sickly sweetness or palate-rasping spiciness in order to anaesthetise the senses and disguise the poor quality of the dish. The outpouring of books and articles about Pollock defies belief. Much of the academic literature is incomprehensible and most of the critical writings entirely vacuous, presupposing that everything that has happened in art since the 1950s stems from Pollock's innovations on the floor of his barn in Long Island. Both are the intellectual equivalents of mindless binge drinking and eating.

I realise that this is a harsh and unforgiving judgement on my part, and I do not make it lightly. I also appreciate that for most Americans the century before 1939, scarred by Civil War, Prohibition and Depression, had not been a happy one. I am aware as well that as an almost wholly immigrant society, the American tradition is to take what you can for

yourself before somebody else gets hold of it first. That was the morality of the Wild West, and it still prevails.

The person who saw the possibility of reinventing his blighted country as the dominant modern world power was Franklin D. Roosevelt. Although his 'New Deal' established public works programmes that got the American economy moving again, what gave him his golden opportunity was the outbreak of war in Europe in 1939. It was his policy to stay out of the European conflict for as long as possible in order to watch the Germans and Russians slaughter each other, and the British Empire bankrupt itself. The longer he stayed out of the war, the more the consequences of these two would deepen, and the greater would be the spoils for the USA to garner.

What forced his hand was not a burning desire to save the best of European civilisation or any sympathy for his transatlantic allies. Following the Japanese attack on Pearl Harbor, Hitler declared war on the USA because he believed that America was a rotting corpse, morally bankrupt and on the verge of collapse. Roosevelt was obliged to reciprocate and so was forced to intervene in the European conflict earlier than he would have wished. Although his hand was forced, Roosevelt played his cards well. I never realised any of this background to American post-war dominance until it was spelled out by a very distinguished American Professor of International Relations whose expertise in the subject is second to none. After 1945 the USA was the pre-eminent nation of the Western world, militarily, economically and politically. It was the Suez Crisis of 1956 that allowed Eisenhower to deliver the fatal blow to Britain as a world power and a rival, and it was the Russian invasion of Hungary in the same autumn that signalled the first turn of the tide in America's favour in the long-drawn-out Cold War.

America's steadily growing but undeniable political, military and economic superiority after 1945 left open the question of where they stood culturally, for their arts had always been but a pale reflection of what had been initiated in Europe. With Abstract Expressionism and the timely dramatic death of Jackson Pollock in 1956 came the opportunity to make American painting the triumphant, commanding, new modern force, a fitting cultural complement to their new-found worldwide

material assertion. Pollock was the ideal figurehead. Unlike most of his fellow Abstract Expressionists, many of whom were European emigrés, he was authentically and undeniably American born and bred, and seemingly untainted by the delicacies and aesthetic considerations associated with European painting. With his 'drip' paintings he had self-evidently produced something which was unquestionably outside the European canon and could unhesitatingly be claimed to be wholly and exclusively American. At last, they had found a champion. From now on European art would be required to dance to America's cultural jingle, in step with their political and economic tunes. He was their final proof that in every way they had at last scooped the pool.

In his farewell speech as President in 1961, President Eisenhower warned about the increasing power of the American corporate industrial-military complex, against the impulse to live only for today, plundering for ease and convenience the precious resources of tomorrow. He looked into the future, and he feared what he saw. His warning came too late. The calamity for both Pollock and America was that neither was forced into selfish choices by circumstances beyond their control. Each had within their grasp a role which could have been truly beneficial. There was a brief moment when each could have chosen to go down a road that would have led to true greatness and earned everlasting respect for championing human values that really mattered. Each would have had to make a difficult decision, pursue a hard road and exercise self-denial. Pollock turned his back, indulgently putting himself and his own material satisfaction first. He was not interested in producing an art for the betterment of mankind. Ultimately, it was all about ME. 'Pollock painting is the subject of Pollock's paintings'. In the same way, America's relentless pursuit of world hegemony has, in my view, little to do with the betterment of mankind. Twenty-first century American society and civilisation, individually and collectively, is, as I see it, obsessed with ME and MONEY. All other considerations take second place.

I must never forget that my comfortable, uneventful life where freedom of speech, peace, prosperity and security have been taken more or less for granted, has been lived under America's protective umbrella, and I am enormously grateful for those blessings. American power, culture and morality have shaped and dominated my world, sometimes for the better and sometimes for the worse. I am also conscious that the young Americans whom I have taught, and with whom I have had many conversations, have two blind spots. They simply cannot comprehend why the rest of the world might not want to get like America; nor can they conceive of a moment when America might not be the tallest poppy in the field and American values might no longer predominate across the globe. Yet even I can see that an increasing number of people in the world no longer want to 'get like America'. During my lifetime I have seen the USA increasingly shy away from

the decencies that it should and could have stood for. Tragically I have witnessed Americans sowing the wind, and now I fear I see them beginning to reap the inevitable whirlwind.

I have no doubt that Jackson Pollock, Andy Warhol and their disciples, maybe even the Trustees and Curators at MoMA, would probably write me off as a foolishly insular utopian, and consider that my belief about the true purpose of art simply shows the extent to which I have lost touch with the real world. They could even be correct in their judgement. In spite of that, however, *Number One* will always be for me a painting of deep meaning and complexity, of significant and original beauty, with personal connections that are important. For me it is a tangible reminder of the extent to which those aspirations and promises which had seemed to be an inherent feature of American society and which were a beacon of hope in my youth, have been squandered. Rather than testing my beliefs to destruction, *Number One* confirms those values that I still believe to be important in both art and life.

Number One matters to me because I do believe that art can be a solace and a source of hope for those whose lives have little joy or reward. If art can bring peace of mind to a troubled soul, even for a brief period as it did for Jackson Pollock, then art has proved its worth. *Number One* is a lasting reminder that art can have a truly redemptive power.

Painterly Reflections by Gino - Pollock

Pollock has found a way to make a painting that is both reliant on the traditions of picture making, while embracing the necessary adventure to realise something completely new. He used cheap utilitarian paints that had the ability to hold their flow, inhibit flux, and dried quickly. How this medium behaved was, for him, fascinating and new. He used sticks, trowels, knives, hardened brushes, and basting syringes to apply these synthetic resin-based Alkyd paints which allowed a fluid application dependent on the distance and speed Pollock was from the canvas, and the finesse he applied. From the correct height or angle, he was able to create wonderful unbroken linear weaves of pattern.

The three-hundred-and-sixty-degree view that he gained by working on the floor was also a different experience. Pollock's dancing rhythms as he gestured and moved forward gave freedom to his hand, and consequently, to the splash and twirl of the paint. As he became more experienced, he constantly refined his analytical considerations and his aesthetic judgements became more sophisticated. The way to spot a Pollock is to look for coiling deposits where the paint pools. If there are too many, then it is unlikely to be a Pollock.

My first visit to America was in 1980 to expand the visual sensibility I had gained looking at paintings in the National Gallery in London. My destination was to the same part of the USA where Pollock lived as a boy. My purpose was to experience life on a working ranch first-hand, travel and understand American urban and rural culture. The landscape on the ranch was sheer magic and the scale was breathtaking. Nature was the ascendant authority with a vastness that was uncompromising. It was the same world that Pollock saw and knew.

Whilst there, I was introduced to a wide network of people who all shared similar backgrounds and social perspectives. However, as an outsider, I could hear and feel the divisions of the different underlying biases and noticed, sometimes through printed signs and posters, the way that other groups were excluded. All around were signs of colonialism and inferred imperialism within a society built on indentured service. The have-nots served the haves and were kept separate.

For me, Pollock created with canvas and paint a colonised landscape, echoing the spirit of the early settlers and the wagon train. Effectively, he has made a painterly land grab that exposes the lie that has long been promoted by America: freedom of expression and the pioneering spirit. In truth, the American Dream is the attainment of wealth and the ownership of riches and people, too many, then who proclaimed Pollock's genius came from within those ranks.

Thanks and Acknowledgements

Firstly, I wish to thank my good friend and neighbour Gino Ballantyne. Over two decades we have worked together on several ventures, and he has drawn, painted and sculpted his take on my appearance many times. He is a natural master of the graphic arts, and his computer design skills are formidable. The appearance and layout of this book, together with the illustrations, are a tribute to Gino's talents and dedication to getting it right.

I never met in person most of those who have had the greatest influence on the way I look at works of art and attempt to write about them e.g. Kenneth Clark, John Pope-Hennessy, Benedict Nicolson, Robert Herbert, John Updike and Robert Hughes. Each of them opened my young eyes and made me think: "Now, that's the way to write about art!". Fortunately I did meet Irving Sandler and he became a lifelong friend. I got a closer insight into Kenneth Clark and Bernard Berenson when editing their correspondence (*My Dear BB ...: The Letters of Bernard Berenson and Kenneth Clark, 1925 - 1959, Yale University Press, 2015*). Both men were passionate about looking at works of art and believed fully in the importance of personal response. Kenneth Clark was able to turn his most acute observations into lyrical readable prose. Bernard Berenson struggled with written words. His forte was the spoken word - not a public lecture - but informal conversation around a dinner table.

I would like to thank everyone at The Lutterworth Press, especially Adrian Brink for allowing the book to evolve at its own pace and young Georgina Melia, whose sometimes overly diffident criticisms and suggestions, have been hugely helpful. When I started to write books, most publishers were concerned with the honing of words and clarity of meaning, or the relationship of text and illustrations on a well-designed page, rather than the bottom line in the annual accounts. Working with Lutterworth Press has been a reassurance that literary and editorial virtues do still exist in the in the publishing world.

I must also acknowledge authorisation from Faber Permissions and Faber Music to quote the lines written by T. S. Eliot on page 116 and the lyrics of *Transatlantic Lullaby* on page 142.

BV - #0071 - 210824 - C0 - 254/178/10 - PB - 9780718897741 - Matt Lamination